IMAGES
of America

EARLY ESCONDIDO
THE LOUIS A. HAVENS COLLECTION

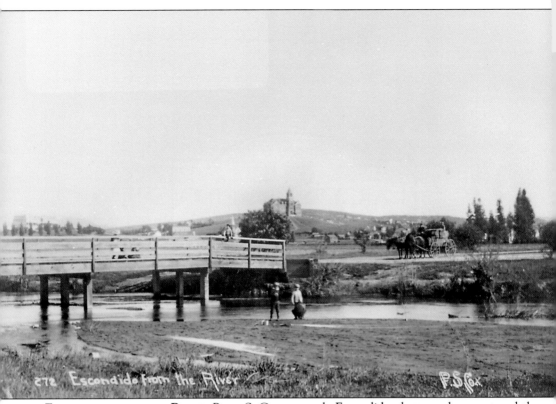

ESCONDIDO FROM THE RIVER. Percy S. Cox, an early Escondido photographer, captured the first constructed bridge crossing the Escondido Creek in the 1890s. Before the bridge, crossing the creek during the seasonal rains was hazardous, as a horseman led wagons across by poking a willow pole into unseen depths to chart pitfalls and quicksand. From left to right in the image, the Escondido Hotel, Methodist Episcopal church steeple, and Escondido Seminary can be seen in the distance. (Courtesy PR.)

ON THE COVER: This rooftop vantage was the scene of the 1929 Grape Day Parade. The parade formed at the Santa Fe depot and proceeded a mile eastward up Grand Avenue through the center of town toward Hotel Hill. The parade and post-parade festivities at Grape Day Park during the 1920s rivaled the Tournament of Roses, attracting thousands of visitors annually and, in the eyes of many, becoming the Southland's grandest celebration. (Courtesy PR.)

IMAGES
of America

EARLY ESCONDIDO
THE LOUIS A. HAVENS COLLECTION

Stephen A. Covey

ARCADIA
PUBLISHING

Published by Arcadia Publishing
Charleston, South Carolina

Printed in the United States of America

Library of Congress Catalog Card Number: 2007933023

For all general information contact Arcadia Publishing at:
Telephone 843-853-2070
Fax 843-853-0044
E-mail sales@arcadiapublishing.com
For customer service and orders:
Toll-Free 1-888-313-2665

Visit us on the Internet at www.arcadiapublishing.com

LOUIS HAVENS, 1930s. This undated photograph of Louis Havens captures him around the late 1930s in Escondido. In accordance with the true photographer, it was usual for Louis to be on the other side of the lens and rarely captured by it. His warmth and professionalism carried his success for many years and shaped the memories of many Escondidans. (Courtesy P. Gillespie.)

CONTENTS

ACKNOWLEDGMENTS

Escondido is my hometown. I was born and raised here, with family continually living here since the mid-1950s. This book has been a journey of discovery as well as a venue for my passion about our Havens family collection.

I would foremost like to thank my father, Cecil R. Covey, for having the childhood curiosity to find these images before they were lost forever and having the foresight to preserve them. I also owe gratitude to the late Frances Beven Ryan, who inspired me as a child to someday write about them. She should also be recognized for her efforts in preserving Escondido history through the creation of the Escondido Public Library's Pioneer Room. Lucy Berk deserves great thanks for her friendship and tireless efforts offering information and editing this work. Additionally at the Pioneer Room, Helene Idels and Nancy Salisbury deserve acknowledgment for their efforts assisting in research. Josef Kasperovich, Cal Poly San Luis Obispo's College of Architecture and Environmental Design (CAED) photographer, was instrumental with guidance of printing and archiving my negatives, while Debbie Seracini at Arcadia Publishing has been brilliant to work with, keeping me paced and inspired. Jeff Frank, columnist at the *North County Times*, and Don Anderson, retired Escondido Community Services director, were helpful in gaining public support during my research.

I feel blessed to have met members of the Havens family—Trudy Havens, Peg Gillespie, Bob Swannie, and Bruce Nelson—who volunteered family imagery while sharing stories of Louis and Esther's life and role in the community.

The Escondido History Center deserves thanks for sharing images of their Havens archive. Director Wendy Barker, Robin Fox, Dick Bartley, and Shirley Buskirk all were kind and supportive, opening their collection and evolving this story from good to superior proportions. Geraldine Beckman and Richard Dotson also deserve credit for contributing private photographs. The late Allen McGrew should be noted for his research in a previous book, *Escondido: Hidden Valley Heritage*.

Lastly I wish to thank my wife, Michelle Covey, and year-old daughter, Alexandra, for always supporting me during this long endeavor.

(Note: Unless otherwise credited, all photographs are from the author's personal collection; courtesy lines for the Pioneer Room and Escondido History Center are denoted as PR and EHC.)

INTRODUCTION

In our fast paced and ever-advancing technological world, it is often difficult for younger generations to realize the significance of what our ancestors had experienced in establishing the places we call home today. It is with this unfortunate irony that we seem to rarely pause to comprehend the history that gives a better appreciation for our heritage.

This book serves as somewhat of a time capsule of such an endeavor. It acts as a narrative of an entrepreneurial artisan who brought the community of Escondido together through his talents and generosity, while depicting much of the region's fledgling years through a collection of images captured on glass plates and plastic negatives. It is this culmination of images that serves to tell a story of Escondido through the photographer's eye as well as a visual record of a thriving Southern California community and its residents.

Louis Alphonso Havens was this artistic entrepreneur. He gained tenure in Escondido as one of only a few businessmen to boast more than 30 consecutive years of operation, from 1911 to 1944. His contributions as a professional photographer during this period have left a legacy that has him long considered the leading recorder of Escondido's early growth and culture.

Prior to Havens, many photographers were attracted to Escondido for its potential business opportunity. Many had temporary stints in the area, setting out advance notices of their arrival in town to perform a week's worth of work; then they would suddenly move on. Others intended to stay, placing notice in the newspaper, renting a storefront, and hoping for business. Their typical reaction was nothing more than a lack of business forcing them to progress on as well. Photographers such as Cox, Fortin, Jacobs, Schellenberg, Slocum, and Waite were such short-lived professionals capturing history from 1886 to 1910, with their rare prints now being considered treasured remnants of early Escondido history.

In 1911, Havens and his bride, Esther, arrived in Escondido from Bishop, California, and bought a small photography studio from then-owner C. C. Jacobs near the southeast corner of Grand Avenue and Kalmia Street. Prior to this time, the studio was occupied by a procession of itinerant photographers. For Havens, timing couldn't have been more perfect to start business in Escondido, as the community was caught in the midst of a land boom after the cancellation of an oppressive water bond debt in 1905. Investors were constructing many commercial and residential buildings, which offered a multitude of business opportunities for the young photographer to establish a successive clientele.

Havens placed his first advertisement in the *Times-Advocate* newspaper in 1911, announcing "Havens Photo Studio—Latest Styles in Portraiture, Views and Kodak Developing—Don't Forget the Place, just south of Avenue House." Locals answered in abundance, prompting the local newspaper to report in the following year that a "substantial building of reinforced concrete was going up on Kalmia Street" to accommodate the expanding Havens studio at 122 South Kalmia Street.

The Havenses occupied an upstairs apartment, conducting business in the ground-floor studio storefront while developing photographs in the basement darkroom with the latest photographic equipment. It was with this presence of quality that the *Times-Advocate* newspaper boasted, "Escondido has every reason to be proud of its photo studio."

In addition to commissioning studio portraiture and repairing photography equipment, Havens offered services such as local and mail-order processing of film for amateur photographers. He also sold custom framing services, stationery, gifts, photo postcards, and art supplies, while Esther ran the storefront and assisted in field work and accounting.

Havens's services were not limited to just studio work. He often packed his field camera, a front-focusing view Rochester Optical "Empire State," to carry out photo shoots for all the local schools, including all shots for the Escondido High School yearbook. His presence was commonplace in the community. He was a predictable presence at Grape Day celebrations, organizational proceedings, festivals, pageants, weddings, and merely around town capturing everyday scenes.

Havens also had various other interests in Escondido. He bought and constructed many downtown properties as business investments. He also found a main source of pleasure in playing a cornet in the old City Cornet Band and spending time with his son, Louis "Jack" Havens.

After his first 15 years, Havens constructed a more modern studio with state-of-the-art equipment at 217 East Grand Avenue. This new building had a very attractive storefront specially constructed with display windows for his photographs. Its interior was spacious and offered ample room for sales and reception purposes to display various art and photographic offerings with a rear garage space used for storage. To one side of the great room, partitioned booths existed for developing, printing, and enlarging photographs. At the rear, a "skylight" studio was available for sittings that allowed unfiltered natural light to enter through north-facing rooftop windows. Its adjoining darkroom allowed ease in changing plates between exposures and offered dressing rooms for patrons. Havens's basement consisted of a modern developing laboratory configured to drain chemicals directly into the city sewer system. It was noted by the *Times-Advocate* newspaper that the studio was "of model quality for the uses of commercial photography which has given Escondido a worthwhile institution."

Havens suffered a great loss in 1931 when fire broke out in his garage and destroyed a vast number of glass negatives along with his 1929 Whippet automobile. Despite this setback, the photographer's work and reputation continued for 14 more years, culminating with the sale of the studio and retirement to the family walnut farm in Santa Ana, California, where he persisted to some degree with photography work and framing in his later years.

Escondidans lost a friend in the community in August 1963 when Havens passed at the age of 81. An obituary commentary from the *Times-Advocate* by Winnie Rogers Hughes, a longtime employee of the Havenses', summed up his contributions and demeanor: "Mr. Havens didn't measure business in terms of dollars and cents. He gave himself like no other person. His philosophy of life was truly based on the Golden Rule and I never knew him to do an unkind thing." It was also noted in Hughes's commentary, "The whole town could be against one and Lou Havens would be the one to extend a friendly hand." It was with this demeanor that Havens found success in binding a community together while preserving its identity for posterity.

In the spring of 1955, a nine-year-old Cecil Covey, the author's father, walked home from Felicita School and up Fifteenth Avenue with a friend. The boys came onto property being developed by a local contractor named Schroeder and discovered a large barn and house, recently demolished and massed into a huge mound. In that heap of rubble were antique furniture, household items, and clothing, along with hundreds of plastic and glass negatives strewn in and around the area.

Cecil and his friend rummaged through the pile of debris and then realized after amusingly breaking dozens of the glass plates that they were a significant historic relic. Cecil grabbed an armload of the slides and took them home. Returning to the site on the following day, Cecil found the pile had been pushed by a bulldozer into a ravine and tracked over, losing all the remaining glass negatives forever.

Cecil retained the treasures that he salvaged in a box for over 50 years until early 2000, when his son, the author, decided to take the fragile, cracked, and eroding images into the darkroom to begin bringing the ghostly figures to reality once again. The negatives, all of Havens's creation, printed wonderfully, some as if they were produced just yesterday.

With the enthusiasm of bringing these images to existence, the author's desire for researching Havens commenced. Through the journey of meeting Havens's descendants and his past clients and through the coordination of local historical groups, this story was taken to new heights. The final product is this collection to pay homage to the iconic photographer who so many in the past knew well, but who few in the present could appreciate—that is, until now.

One

SEARCHING FOR IDENTITY
EARLY YEARS IN ESCONDIDO

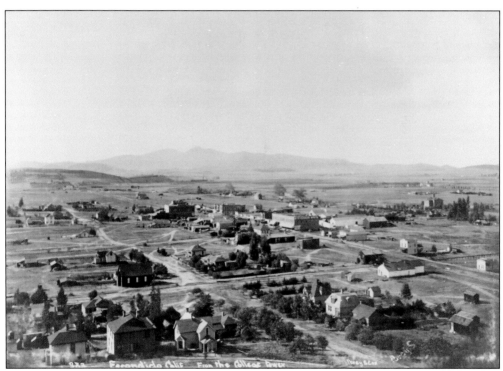

ESCONDIDO TOWNSITE FROM COLLEGE TOWER, 1890S. Escondido, born March 1, 1886, steadily grew to incorporation on October 8, 1888. As seen from the seminary vestibule in the early 1890s, the fledgling city is nestled in a broad valley surrounded by hills offering plenty of opportunity for development. Grand Avenue, at right of center, was the business spine of the community, bounded on the west by the Santa Fe train depot and the east by the swank Escondido Hotel. (Courtesy PR.)

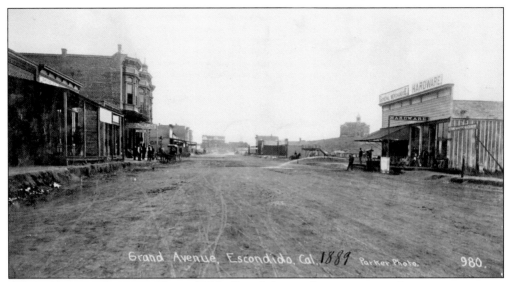

GRAND AVENUE LOOKING EAST, 1889. Grand Avenue began gaining identity as structures sprang up near the intersection of Lime Street in 1889. The dusty expanse had to be sprinkled regularly to settle and compact the rough surface. Buildings sat high off the street to alleviate flooding, with boardwalks linking businesses to keep people off the mud and dust. In the distance looms the Escondido Hotel, with USC Seminary towering in the background and Graham and Steiner Hardware at right. (Courtesy PR.)

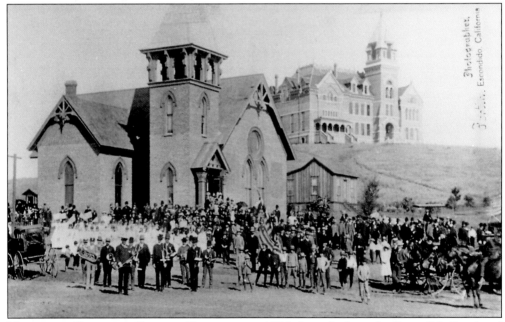

METHODIST EPISCOPAL CHURCH DEDICATION, 1886. In early days, the Escondido Land and Town Company offered free land to churches for development. Seven faiths accepted, and in 1886, the Methodist Episcopal Church was the first to build a house of prayer on East Grand Avenue. Made of red brick, then handmade in Escondido by Chinese workers, the church was dedicated to the public in 1886 with sweetly toned bells calling the faithful to come worship, as captured in this dedication day image by early traveling photographer J. Fortin. (Courtesy PR.)

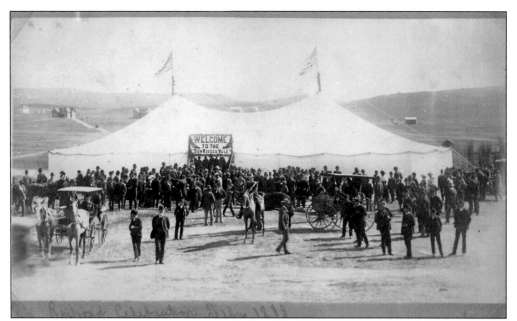

RAILROAD ARRIVAL CELEBRATION, 1887. Escondidans jubilant about the California Southern Railroad gathered for a welcoming of the first train on December 31, 1887. A year prior, the Escondido Land and Town Company put forth $100,000 toward building the line to Escondido. Excitement was cut short as the engine sank into river sand at an untrestled crossing between Oceanside and Escondido, leaving the hosts at the end of line to find news that the train could not make it. (Courtesy PR.)

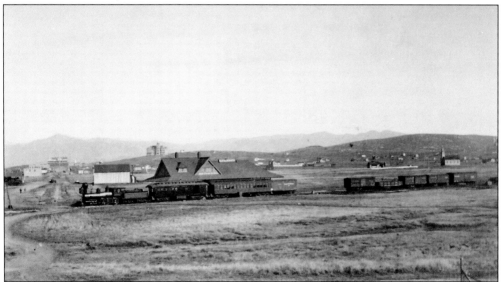

RAIL DEPOT AND ESCONDIDO VALLEY, 1890S. Escondidans considered the train the financial backbone of the region. A typical week's shipment of goods out of Escondido in the early 1900s equated to 128 cases of eggs, 1,093 pounds of butter, 1,290 pounds of vegetables, 1,130 pounds of cream, 1,085 pounds of chicken, 1 car of oranges, 1 car of lemons, and 4 cars of hay. In this 1890s image, a series of various cars can be seen and both coaches for personal travel and freight are staged at the station. (Courtesy PR.)

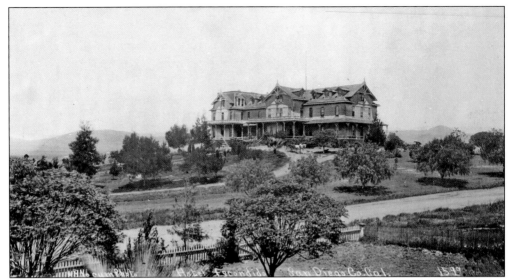

ESCONDIDO HOTEL, 1893. Escondido boasted an elaborate hotel as the Escondido Land and Town Company constructed a 100-room structure for $50,000 at the upper end of Grand Avenue. Originally built as a visionary part of the future community, the hotel first housed persons interested in land purchases and then became a social hub of the community for gatherings and parties. Business persisted strongly from the opening day in 1886 until its demise in 1920. The hotel was demolished in 1925, and today Palomar Hospital occupies the original site high above town. (Courtesy PR.)

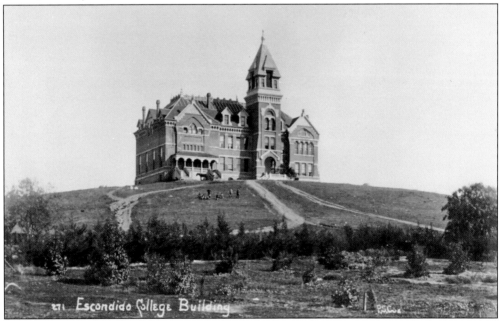

ESCONDIDO SEMINARY, 1893. Incorporated in 1887 as a branch campus of the Methodist University of Southern California (USC), the red brick towering landmark, later known as Escondido High School, began as a venture by USC to create a series of colleges in Southern California. Its success as a college was short-lived, and in 1894, it was deeded to Escondido School District. Rooms were large and airy with fireplaces, mantels, grates, and fine woodwork. (Courtesy PR.)

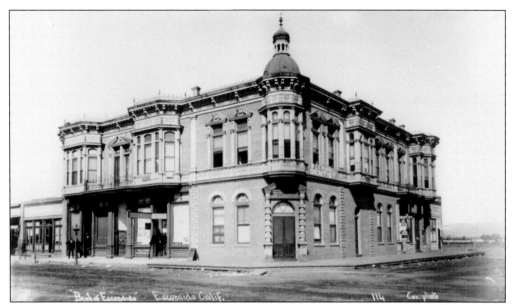

ESCONDIDO NATIONAL BANK, 1890s. The ornately domed and windowed red brick Escondido National Bank was constructed by the Escondido Land and Town Company in 1886. It was sold to A. W. Wohlford in 1892 amid a financial panic and persisted as the only bank locally to survive. Offices of the Land and Town Company were located on the lower right floor. The building exists today, yet it has unfortunately lost most of its original character because of architectural renovations. (Courtesy PR.)

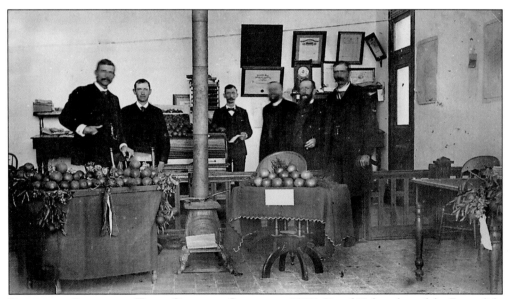

ESCONDIDO LAND AND TOWN COMPANY OFFICIALS, 1887. Six of 10 founders of the Escondido Land and Town Company strike a pose for an early photographer inside their storefront office on Grand Avenue and Lime Street in 1887. Organizers of the company bought the deed to the 12,813-acre Rancho Rincon Del Diablo for $104,000 from the Escondido Company and sparked a land boom through planned development and marketing of the "hidden valley." (Courtesy PR.)

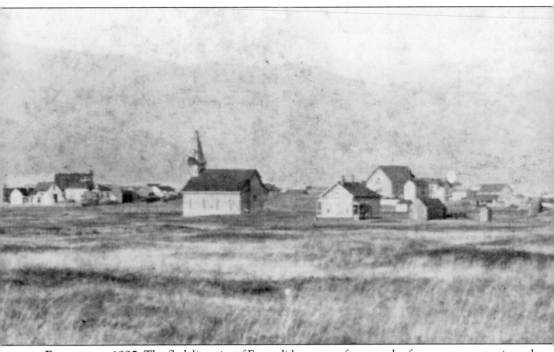

ESCONDIDO, 1895. The fledgling city of Escondido, as seen from south of town near approximately Fifteenth Avenue and Center City Parkway, was not much more than a tiny accumulation of businesses, homes, and hay fields in 1895. These two unidentified girls had plenty of space to

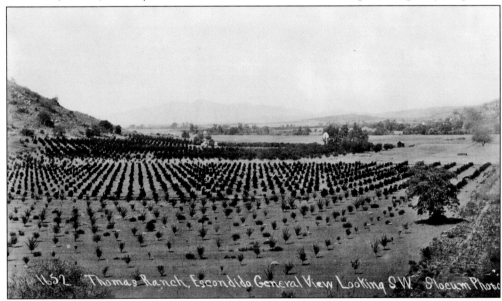

THOMAS SHOW RANCH, 1900. R. A. Thomas, of the Escondido Land and Town Company, acquired land east of Escondido, near present-day Valley Parkway and Washington Avenue, for experimenting with citrus production and other farming practices to market the Hidden Valley's agricultural potential. The ranch popularized Escondido's perfect climate, becoming a successful marketing tool to potential land buyers. It was sold and expanded to 500 acres in the early 1900s and evolved to become the region's largest lemon producer. (Courtesy PR.)

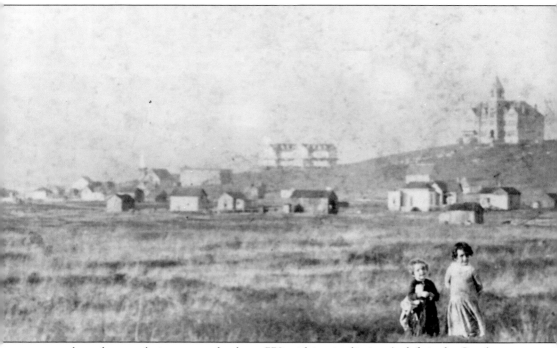

run around, as the population was only about 770 within city limits. At left is the Southern Methodist church, one of the original seven churches. At right are the Escondido Hotel and USC Seminary. (Courtesy PR.)

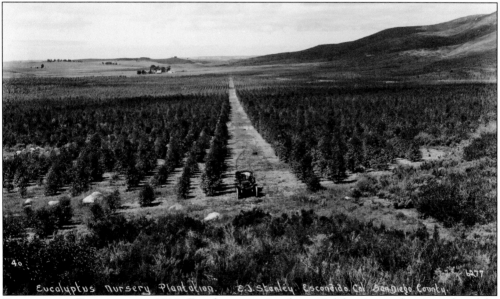

EUCALYPTUS PLANTATION, 1910. Eucalyptus in Southern California was first introduced for timbering uses. The railroad industry reasoned they could make ties out of 15 years' growth for the ever-growing railroad infrastructure. To meet demand, Pratt Eucalyptus Company planted 700 acres in Escondido. By 1910, this plantation was on its way to becoming a forest. Speculated qualities of fast growth, quality timber, and quick maturity were dashed when trees on poor soil would struggle and wood for lumber twisted and split. (Courtesy PR.)

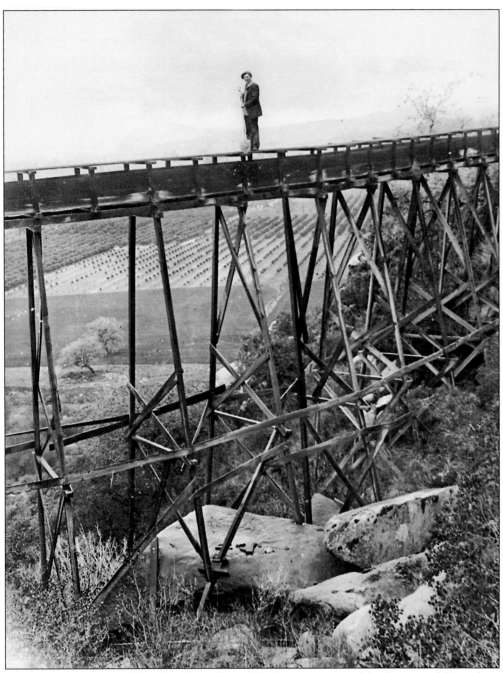

GAMBLE FLUME, 1914. Water brought to Escondido for irrigation and drinking was delivered via an extensive 15-mile network of hand-dug canals, tunnels, and flumes from the upper San Luis Rey Watershed. Although fragile in stature and quite leaky, the wooden flumes were invaluable in traversing water over canyons and gullies at a subtle slope, delivering to Bear Valley Dam at Lake Escondido. Pictured here on the flume, just prior to its modernization by cement pipe, is Sidney Gamble, one of the Escondido Mutual Water Company directors. (Courtesy PR.)

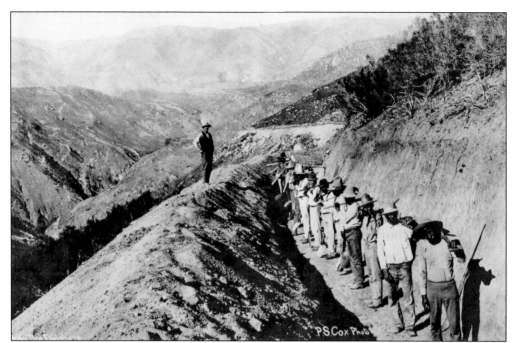

ESCONDIDO CANAL DIGGING, 1894. Escondido planners and residents understood early that harnessing a reliable water source was the key to their developmental, agricultural, and ranching success in the region. Realizing the need to seek a substitute to early, undependable wells, the Escondido Mutual Water Company directed teams and hand labor, under a $350,000 bond act in 1894, to dig the series of waterways, which delivered the water into the Bear Valley Watershed. The project was completed with delivery of the first irrigation water to the valley on July 5, 1895. (Courtesy PR.)

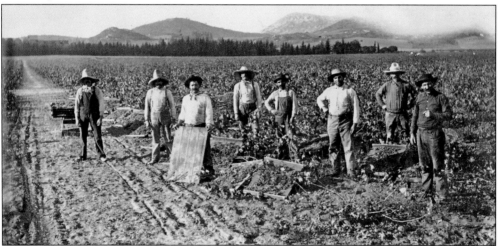

THE BIG VINEYARD, 1880s. The perfect Southern California climate paired with fertile soils judged to be ideal for grape growing in Escondido. In 1882, fifteen men paid $128,738.70, approximately $10 an acre, to acquire and plant 100 acres with muscat grapes as the Escondido Company. In 1884, rains mired their plans to further develop the valley as a big vineyard. As a result, the company sold their interests to the fledgling Escondido Land and Town Company for development purposes. (Courtesy PR.)

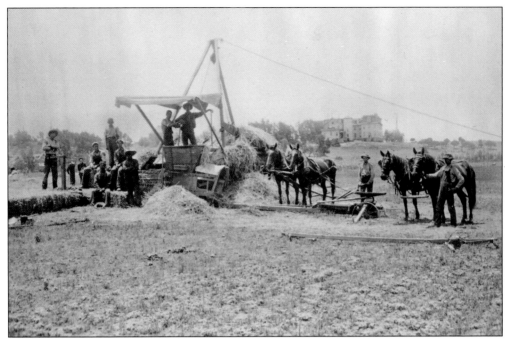

HARVESTING HAY, 1900. A staple commodity in early Escondido was dry farm haying. It began annually with a spring ploughing of the soil and broadcasting alfalfa or sorghum seed, which sprouted with spring rains, growing to maturity in the early summer sun. The harvest in late summer filled the air with the aroma of freshly mown pasture, as baler crews worked around Escondido to cut, bale, and ship the product for winter fodder. This crew is Ramon Montiel's baling outfit taking a break in a pasture northwest of the Escondido Hotel. (Courtesy PR.)

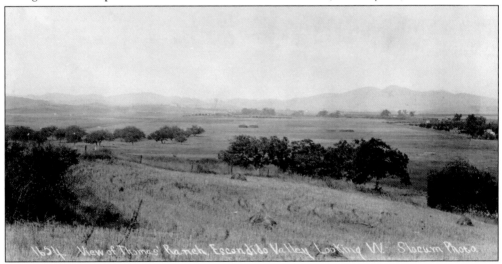

ESCONDIDO VALLEY NORTHWEST, 1890S. In this 1890s photograph by J. E. Slocum, the Escondido valley spreads out towards the distant western hills near San Marcos, depicting the vast expanse of fertile land. At the eastern end of the valley, dry hay farming was a major practice on the rolling hills interspersed with native Engelmann oaks and the riparian Escondido Creek at right. The oaks left of center created La Huertita or "little grove," where the current Orange Glen School is located. (Courtesy PR.)

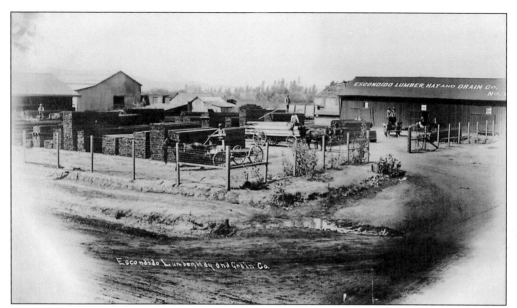

ESCONDIDO LUMBER, HAY, AND GRAIN COMPANY, 1900. In this undated *c.* 1900 photograph, the Escondido Lumber, Hay, and Grain Company is already flourishing as a successful business providing the growing city with building materials and acting as the agent for local hay and grain producers to take products to market. Builders queue their wagons in the northeast portion of the yard for loading adjacent to the No. 1 stockpile barn for milled lumber. (Courtesy PR.)

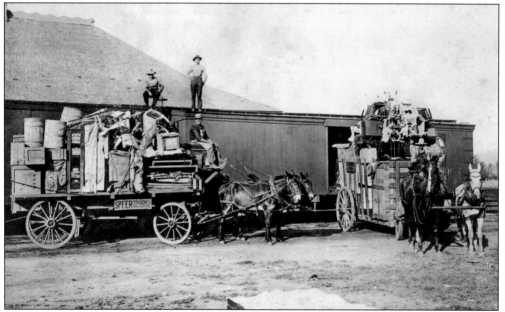

MOVING IN, 1900. Mule skinners for the Speer Truck and Transfer Company, with their teams and lowboy freight wagons, pose for a photograph after unloading an Atchison, Topeka, and Santa Fe Railroad railcar at the Escondido Depot. Contracted by new settlers, these "skinners" or mule team masters would haul freight and home furnishings from the depot to homes, businesses, and ranches. Mules were much more reliable than horses for hauling cargo, including the piano crate on the front lower right wagon. (Courtesy PR.)

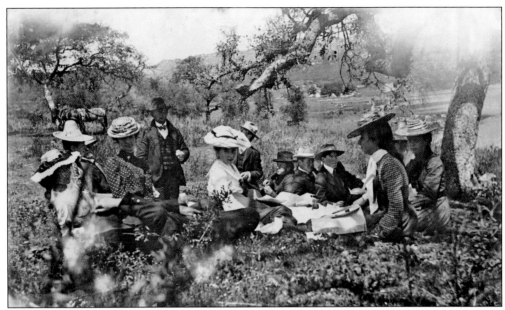

PIONEER PICNIC, 1900. Turn-of-the-century pioneers would take Sunday afternoons for some rest and relaxation under the oaks after long hours of work during the week. Such events were opportunities for locals to catch up on gossip and family happenings. This group rests in a meadow in northwest Escondido near the old Wolfskill Ranch. (Courtesy PR.)

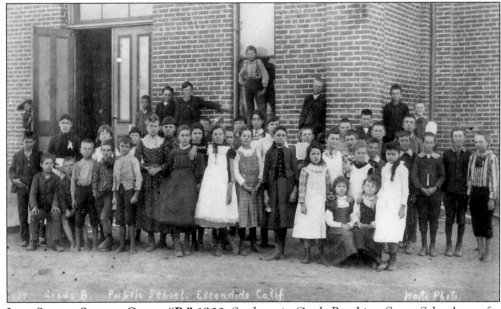

LIME STREET SCHOOL GRADE "B," 1900. Students in Grade B at Lime Street School pose for traveling photographer Waite in this c. 1900 image. The school, built by the Escondido Land and Town Company in 1886 on the future site of Grape Day Park, was deemed unsafe in 1909 and torn town because of subsidence into the Escondido Creek. It appears that for the time, the schoolteacher had her hands full with some perhaps unruly boys. (Courtesy PR.)

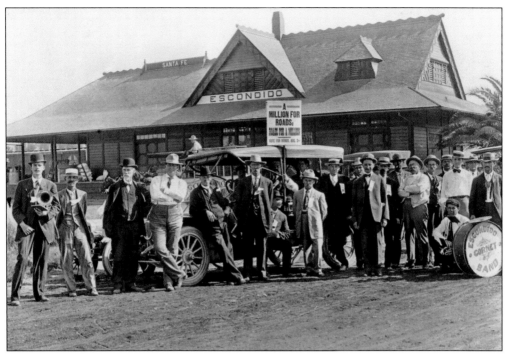

GRAPE DAY GREETING COMMITTEE, 1909. At early Grape Days, a "glad-handing" committee consisting of four founders greeted the special train at Oceanside bound for Escondido. Shaking hands and pinning each visitor with a shiny Grape Day badge, they became a symbol of warmth and welcome. In Grape Days to follow, these glad-handers and the Escondido Cornet Band waited at the Escondido Depot to offer greetings in grand fashion. (Courtesy PR.)

EARLY PHOTOGRAPHER'S ADVERTISEMENTS. As seen in these clippings from the *Escondido Times* in the early 1900s, locals had to plan to get their photographs taken as the chance each year was limited. The few experts that did pass through the area—Waite, Slocum, Cox, Jacobs, and Schellenberg—either worked out of their mobile wagon darkrooms or in rented storefronts. (Courtesy PR.)

Photographing

Mr. C. C. Jacobs, from the east, has secured the Photograph gallery on Kalmia Street and will be open for all kinds of Portrait work and viewing. Also all kinds of Amateur work will receive prompt attention.

C. C. JACOBS.

Coming Again.

I will reopen my Escondido Studio again Thursday, September 8th and remain there till Monday, September 12th, inclusive. Now is the to get your Xmas Photos as another trip to Escondido is uncertain, as my San Diego Studio requires practically all my attention.

M. O. Schellenberg

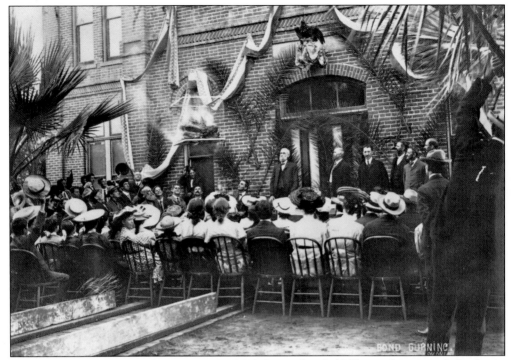

BURNING OF THE BONDS, SEPTEMBER 9, 1905. September 9, 1905, stands as a symbolic day in Escondido's history, as a procession of citizens paraded up Grand Avenue to Lime Street School to celebrate the burning of $228,000 in water construction bonds. The celebration at the steps of the Lime Street School marked a victory in the city's efforts to secure financial freedom and reliable water sources. (Courtesy PR.)

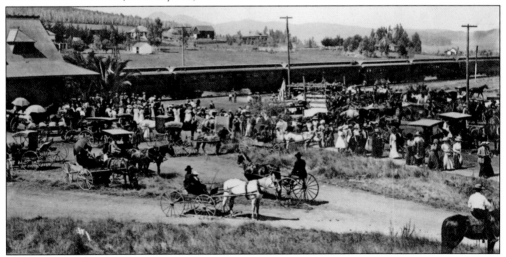

FIRST GRAPE DAY, SEPTEMBER 9, 1908. Escondido's Grape Day Celebration grew out of desire not to forget Bond Burning Day in September 1905. Each September 9, families with full picnic baskets celebrated the happy event. Sig Steiner, a 12-year Escondido mayor, proclaimed September 9 should be a celebration of the future, not of the past, and should publicly market Escondido and its most productive bounty: grapes! The people came via train and automobile, and a 32-year tradition was born. (Courtesy PR.)

Two

A LOCAL ERA BEGINS
THE HAVENS' STUDIO

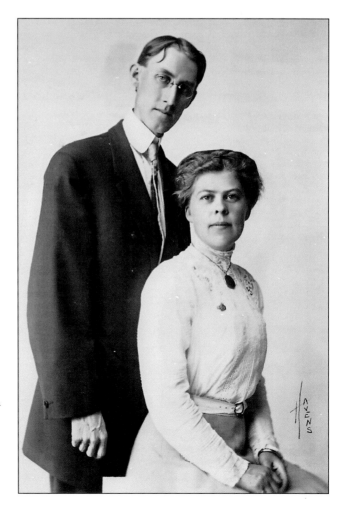

LOUIS AND ESTHER HAVENS. Escondidans welcomed the Havenses but wondered if a photographic business could flourish in the back-country town. The honeymooning Havens couple traveling through Escondido late in 1910 liked what they saw and decided to settle in the "Hidden Valley." Their photograph contributions to Escondido during the first half of the 20th century are invaluable as a historic document and social record. (Courtesy PR.)

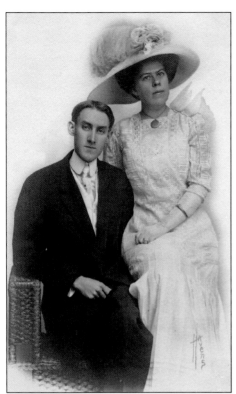

LOUIS AND ESTHER HAVENS, 1910. Louis, 27, and Esther, 23, came from Bishop, California, where they had a small photography studio in late 1910. It is speculated that they shot this self-composed wedding portrait together in that first studio. The use of a pneumatic bulb release by squeezing a hand-held bladder via a long hose that depressed his shutter allowed him to sit in the image. His concealed hand most likely hides this apparatus. (Courtesy P. Gillespie.)

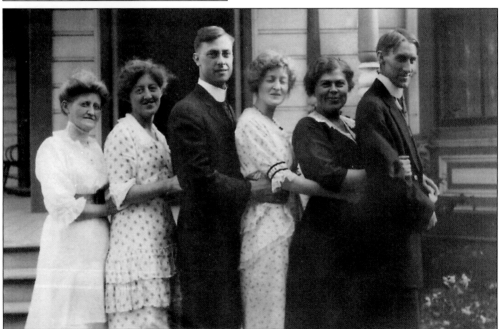

HAVENS FAMILY, 1919. A partial Havens family portrait in 1919 at Louis's parents' walnut ranch in Santa Ana was possibly shot by another family member. From left to right are Louis's mother, Josephine; sister Hazel; brother-in-law Bruce with his wife, Louis's sister Edith; Esther; and Louis. (Courtesy P. Gillespie.)

Havens Photo Studio

Latest Styles in
PORTRAITURE, VIEWS, AND KODAK DEVELOPING

Don't forget the place, just south of Avenue House

HAVENS' STUDIO GOES PUBLIC, 1911. The Havenses' first shop was located in a small Grand Avenue structure previously occupied by a series of unsuccessful photographers. As this building was less than desirable, Louis embarked on the construction of a modern studio at 126 South Kalmia Street, debuting in 1911. Living in an upstairs apartment, they conducted business on the ground floor and basement. Havens placed his first advertisement in the *Times-Advocate* newspaper in 1911, announcing "Havens Photo Studio—Latest Styles in Portraiture, Views and Kodak Developing—Don't Forget the Place, just south of Avenue House." Constructed in collaboration next door was Marikle's Studio, a music shop run by John Marikle. (Courtesy PR.)

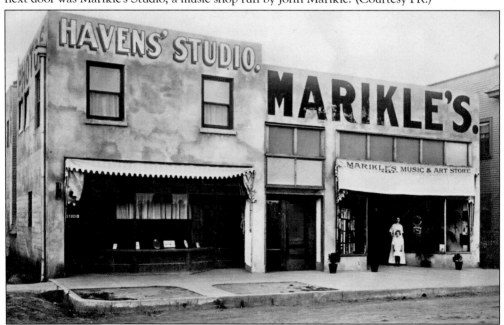

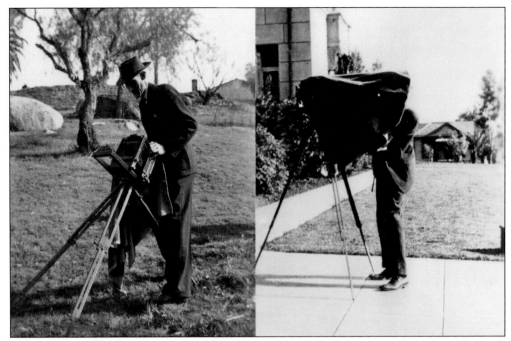

HAVENS AND HIS CAMERA. Before photographic apparatus was made of plastic and metal, beautiful cameras were handcrafted of finely polished woods, brass, and leather. The golden age of wood cameras lasted from the birth of photography in 1839 to the early part of the 20th century. It is speculated that Louis primarily used a *c.* 1911 Rochester Optical "Empire State" front-focusing view camera in his early days, as seen in these photographs as he sets up for a shoot. (Courtesy EHC.)

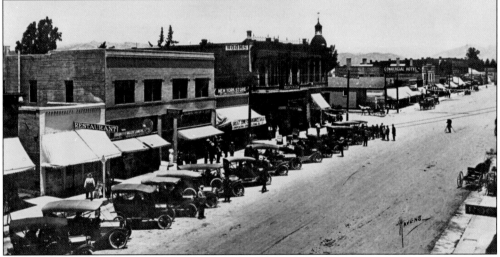

HAVENS ON GRAND AVENUE, 1914. For 34 years (1910–1944), a familiar sight on any Escondido Street and at any public event was photographer Havens with his camera equipment set up to photograph everyday sights, important proceedings, and the ever-growing landscape of the city of Escondido. This shot depicts Havens, seen in the center of Grand Avenue, under his black tarp with camera, photographing a group of real estate dignitaries in front of the Escondido Land and Town Company. (Courtesy PR.)

JACK HAVENS DOUBLE EXPOSURE, 1920. This double exposure of Louis's son, Jack Havens, on one glass negative stands as a unique image as it may be an attempt by Louis to adjust his camera settings by bracketing exposure. He was also experimenting with his signature etching on negatives, which required a steady hand.

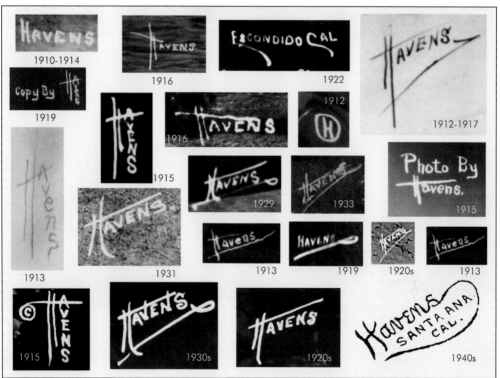

HAVENS'S SIGNATURES OVER THE YEARS. Havens's signature evolved over the years almost as much as the places and people his lens captured. Upon researching his imagery for this publication, a pattern of dates could be established by comparing signature styles with an approximate era of its creation. This pattern of recognition assisted greatly in identification of mystery images and dates. The simplicity of his signature became a trademark style of his work.

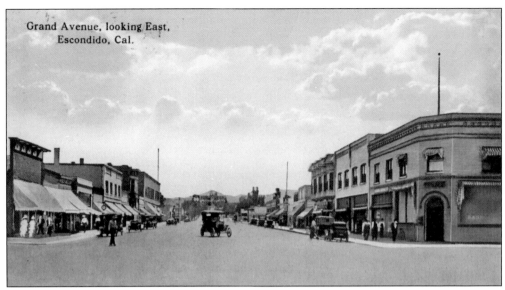

GRAND AVENUE HAVENS POSTCARD, 1911. Louis and Esther Havens found a successful marketing niche for their studio shop of printing and selling hand-colored postcard images of local scenery. At a bargain 2¢ each, these postcard views, such as this shot of Grand Avenue in 1911, became popular souvenirs for visitors to send to snow-weary Easterners. A sampling of similar postcards shows a variance in color depicting the hand-painted qualities. (Courtesy EHC.)

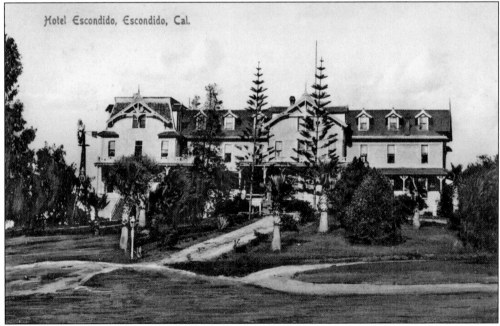

ESCONDIDO HOTEL HAVENS POSTCARD, 1915. During the 1915–1916 Panama-California Exposition in San Diego's Balboa Park, the Escondido Hotel was booked to capacity, with every room taken at $2–$2.50 per day. People from near and far signed the hotel register, many passing through never to return, others settling in the area. Many declared that being unable to get a room in the San Diego area was the best thing that happened as they found and fell in love with Escondido. (Courtesy R. Dotson.)

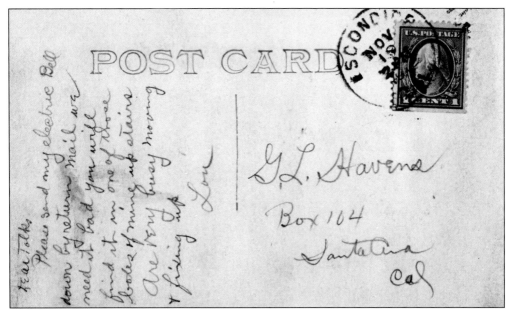

GRAND AVENUE HAVENS POSTCARD, 1911. Many folks, including Havens, used his postcards for communicating to friends and family with everyday notes, messages, and well wishes. On the back of Havens's Grand Avenue postcard, Havens addresses his folks asking for an electric bill that was left in a box while moving into his Kalmia Street studio. As noted, late 1911 held busy times for Louis and Esther in setting up their new shop. (Courtesy EHC.)

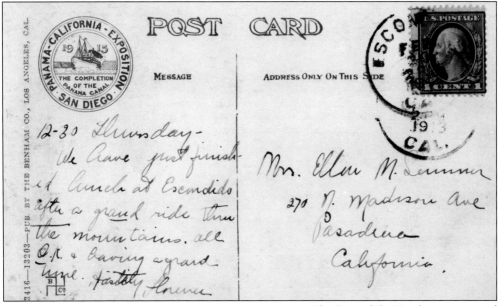

ESCONDIDO HOTEL HAVENS POSTCARD, FEBRUARY 1915. The Escondido Hotel commissioned Havens several times to conduct prints of postcards for advertising purposes. This February 20, 1915, cancellation boasts a message of well wishes during the Panama-California Exposition in San Diego. Many visitors passing through stopped at the hotel and forwarded on a postcard to relatives, many times inadvertently sparking interest in the recipients to come visit themselves. (Courtesy R. Dotson.)

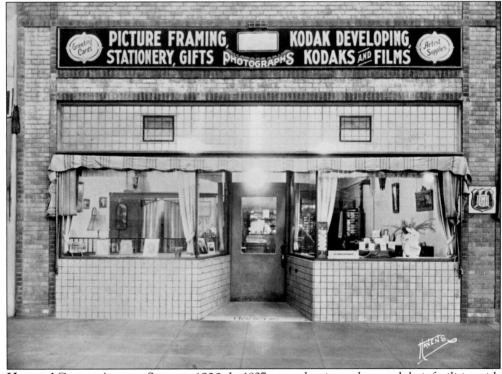

HAVENS'
STUDIO and ART SHOP
217 E. GRAND AVE. ESCONDIDO, CAL.

ORDER No..................... DATE.....SEP 23 1936....

NAME...*Mr. Wallace Stewart*...........................

ADDRESS...

Developing:	Rolls @........	.15
Printing:..Gloss....Matte @ 6¢	30	
Enlargements:........@ Each	01	
Coloring:........................		
Framing:.........................		

TOTAL, $.46.

PICTURE FRAMING . . . ART GOODS
GREETING CARDS . . . KODAKS and FILMS
CHILDRENS PICTURES A SPECIALTY

HAVENS' STUDIO WORK ORDER, 1936. In addition to photographic and portraiture services, developing, camera repairs, and framing and mounting of images, Louis Havens also offered Escondidans a variety of notions and goods ranging from artist supplies and greeting cards to local postcards and office stationery. This work envelope for developing and printing was used by Havens to conduct much of his 24-hour turnaround services at very reasonable prices, even for 1936. (Courtesy PR.)

HAVENS' GRAND AVENUE STUDIO, 1930. In 1927, to modernize and expand their facilities with the popularity of their swelling business, Louis and Esther constructed a fireproof concrete building at 219 East Grand Avenue. At the most contemporary photograph studio and darkroom in every aspect, "Havens" was tiled at the threshold, leading the customer into modern amenities, such as skylighting for studio shots, a modern darkroom plumbed to the sewer, ever-changing window displays, and a storefront offering art supplies and notions. (Courtesy PR.)

Three

THE EXISTENCE
OF THE COMMUNITY
AGRICULTURE AND WATER

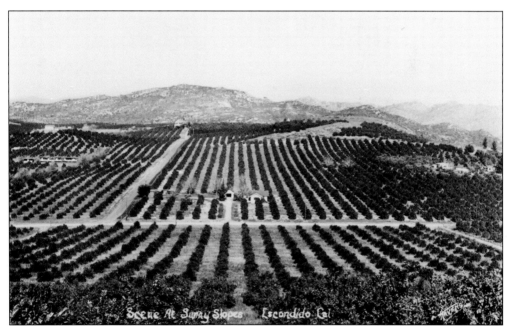

SUNNY SLOPES CITRUS, 1920S. Sunny Slopes Ranch, southeast of Escondido, was the scene for Havens's camera to capture an idyllic Southern California shot of the successes of the citrus growing industry. He often traveled around the area with his field camera, tripod, and glass negatives bound in a light-tight box and composed photographs that he knew would sell as postcards in his studio shop to tourists and locals alike. (Courtesy EHC.)

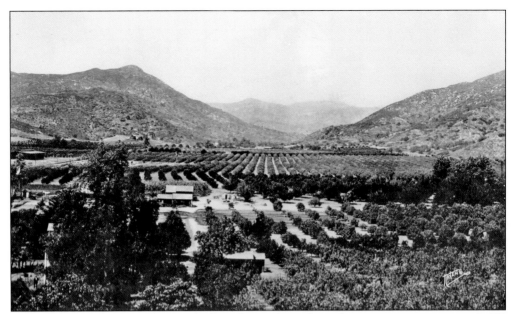

EUREKA RANCH, 1913. The Eureka Ranch was formed as a business venture among A. W. Wohlford, G. R. Crane, F. E. Boudinot, and A. Beven in 1906 and persisted as a 500-acre citrus ranch until 1918. The original property was the R. A. Thomas Show Ranch as seen on page 14. To the hills east of the ranch in the background lie Valley Center and Bear Valley Dam. The ranch was divided among the four in 1918, ceasing its formal operations. (Courtesy PR.)

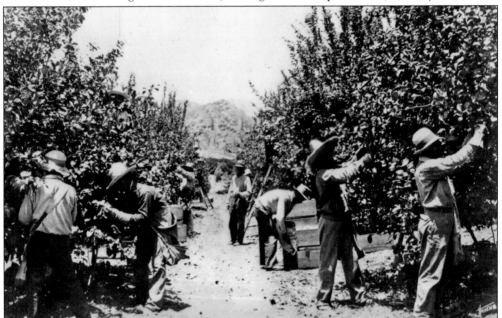

PICKING LEMONS ON EUREKA RANCH, 1913. Workers busy picking lemons on Eureka Ranch had their hands full with not only picking, but planting new trees, cultivating, irrigating, fertilizing, pruning, fumigating, and frost protecting the trees. Lemons proved to be the best crop out of all citrus planted, as they blossomed and grew on several pickings a season. All fruit that was picked was processed in a packinghouse on the ranch. (Courtesy PR.)

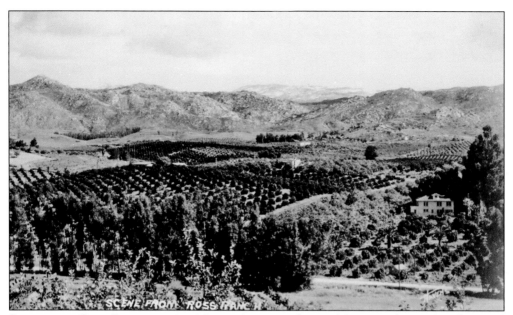

SCENE FROM ROSS RANCH, 1930. Matzen Acres, southeast of Orange Glen High School and Oak Hill Cemetery, was a prolific citrus producing area on the outskirts of the valley's east end near San Pasqual Road. This view from adjacent Ross Ranch shows the rolling hills to the east, which offered protection while south-facing slopes gave plentiful solar exposure to ensure a thriving citrus crop. Havens's skill at composing scenic landscape imagery was always worth a postcard. (Courtesy EHC.)

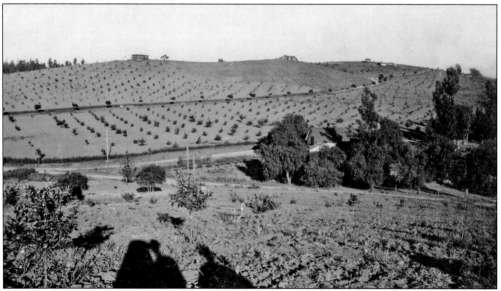

HOWELL HEIGHTS FROM WEST, 1915. Young lemons take root on slopes west of Escondido in this 1915 exposure with the road to Del Dios and Lake Hodges Dam crossing from right to left in the mid-ground. Without modern light meters and gadgets, Louis and Esther made "bracketing" exposures to get light qualities and aperture settings correct. Most likely, this image where their shadows are present was one of these throwaway exposures made prior to the final image. (Courtesy EHC.)

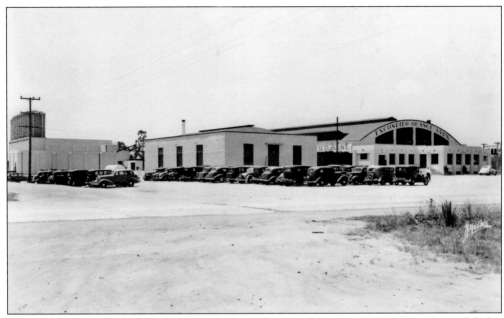

MODERNIZED ESCONDIDO CITRUS PACKING, 1929 AND 1934. Citrus packing in Escondido hit its height from the 1930s to the mid-1940s with Sunkist coming to town. The Sunkist Lemon Packing House, as seen shortly after opening in 1929, was located at the western side of Escondido, between the Santa Fe railroad and Tulip Street. The packinghouse, designed in the mission revival style by architect J. Rex Murray, was constructed on a sloping site to maximize simplistic loading onto railcars and also had an ice-making plant and precooling system. The Sunkist Escondido Orange Association later constructed a modern packinghouse on Mission Avenue in 1934 that standardized and separated the two operations as one packinghouse could not support the demand. (Courtesy PR.)

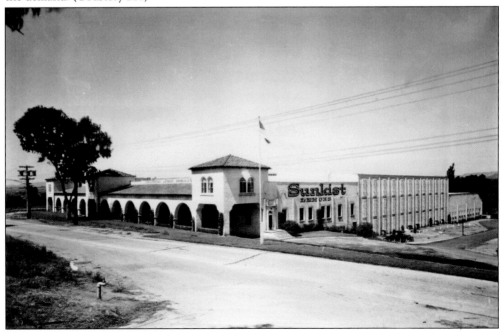

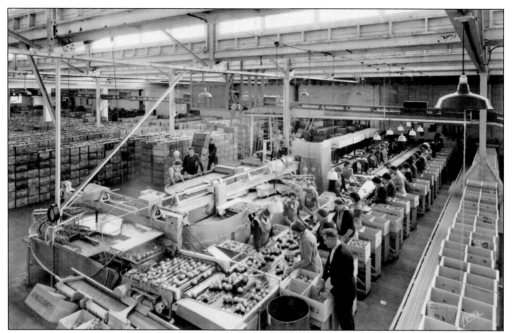

WASHING AND GRADING LEMONS, 1936. The Escondido Lemon Association boasted the largest packinghouse in the region, packing over 800,000 field boxes of lemons annually. This Havens image follows the washing and grading of the fruit as it is inspected for blemishes, sorted per size and quality, and placed into crates for pre-packing. The crates in the background bear the stamp of the Escondido Lemon Association, while the crates being filled are for the California Fruit Growers Exchange. (Courtesy EHC.)

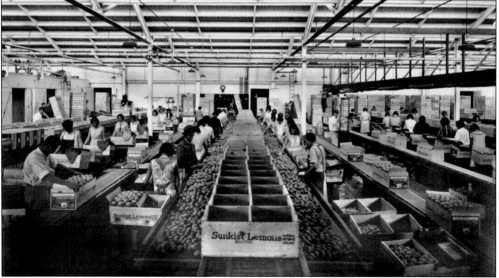

PACKING LEMONS, 1936. Once washed, graded, and sorted into pre-packing crates per their destination, Escondido lemons made a final trip down another series of conveyors for the final sort into product box crates. These final crates displayed varying packing labels through the California Fruit Growers Exchange, such as Liberty Brand, Hidden Dale, and Wonderland, all under the Sunkist brand. (Courtesy EHC.)

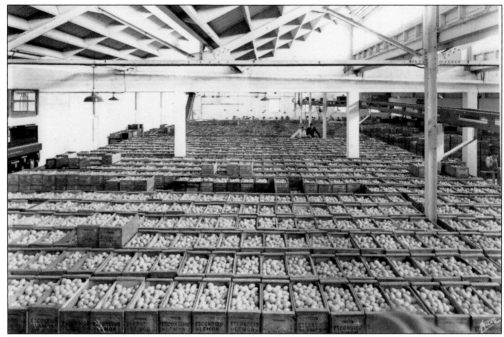

READY FOR SHIPMENT, 1936. Havens captured approximately 7,000 crates of Sunkist lemons inside the packinghouse, of which these approximately 850,000 lemons were just a fraction of the crop processed in a year. Packinghouses were often uncomfortable working environments, with extremes in temperature, long hours, and monotonous duties. The Sunkist Escondido Lemon Association's packinghouse, however, was very modern, with regulated temperatures and soft natural light via a sawtooth shed roof to ease inspection. (Courtesy EHC.)

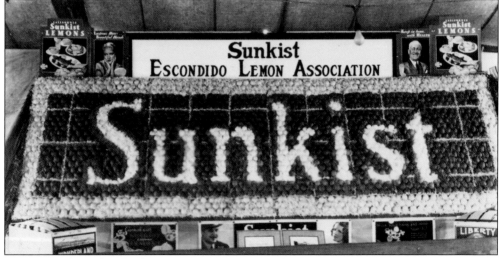

SUNKIST ESCONDIDO LEMON ASSOCIATION, 1935. The Escondido Sunkist Lemon Association commonly used the local county fairs, Grape Days, trade shows, and expositions as well as those across the country to market their product. Havens photographed displays for Sunkist and created postcards to spread the word of the lemon bounty afforded by the California climate. This billboard-like display must have taken some time to create with each lemon wrapped in fancy colored tissue. (Courtesy PR.)

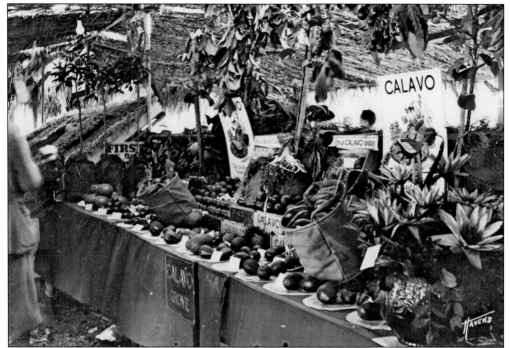

EARLY AVOCADO INDUSTRY, 1938. In the 1920s, avocado ranchers gained popularity with fruit that thrived in the perfect climate. Distribution was done via local packinghouses. In 1926, to boost identity, the California Avocado Growers Exchange conducted a contest for a nationwide brand identity. F. F. Eberts, a local rancher, proposed "Calavo" as the winning brand name out of several thousand entries. The name stuck, and at every Grape Day, festival, and fair, Calavo avocados were a prize entry. (Courtesy EHC.)

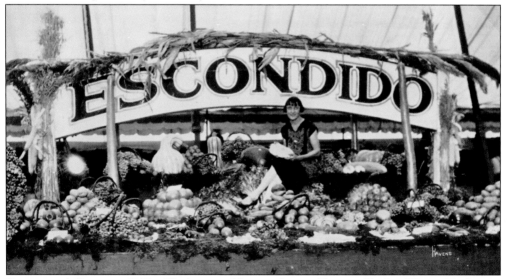

ESCONDIDO'S BOUNTY, 1920s. The bounty of fruits and vegetables raised by local Escondido farmers and ranchers was plentiful during all seasons. The chamber of commerce wanted it to be known that these wonderful crops grew in the "Hidden Valley," and as such, Pansy Claggett of the chamber had a knack for making prize-winning displays at each festival and fair. (Courtesy PR.)

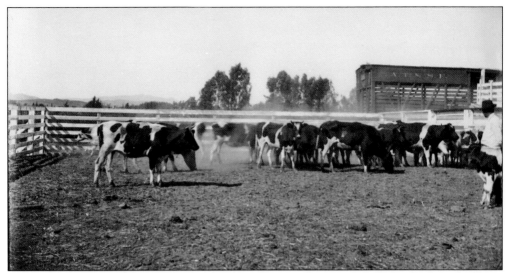

ESCONDIDO STOCKYARDS, 1915. Escondido's stockyard adjacent to the Escondido Lumber, Hay, and Grain Company at Grand Avenue and Quince Street was a bustling area each spring as Holstein cattle were loaded and off-loaded in corral holding pens to be sold to local dairymen or shipped to market. This dusty image for Havens may have been a challenge to capture as movement often preceded focal clarity because of slower shutter-speed exposure times.

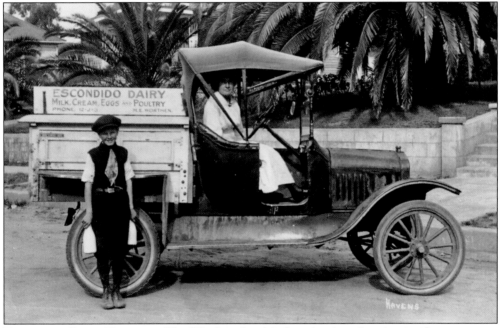

ESCONDIDO DAIRY DELIVERY. The Worthen family's dairy herd produced a significant amount of milk beyond what they could consume on a daily basis. Realizing profits to be made, Mary Worthen, the eldest daughter, began an enterprising family business transporting milk to local residents around Escondido. In approximately 1921, Havens captured her and 10-year-old door delivery boy Charlie Socin with her new Ford pickup, recently upgraded from a horse-drawn wagon. This truck ensured Worthen as the first successful motorized dairy service in the region. (Courtesy PR.)

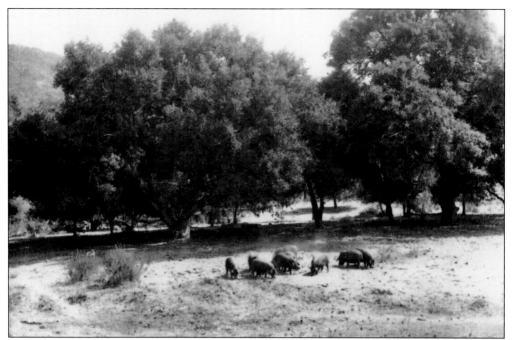

PIG FARMING, 1920. Not being content with staying in the studio, Havens quite often took his camera out and roamed the countryside, capturing many scenes of local farming and agriculture with his wooden field camera. Clustered among of a group of mature oaks and being carefully watched by a herding dog, these gilt hogs, which may have been raised for meat or sow breeding, are seen taking in a day's feed.

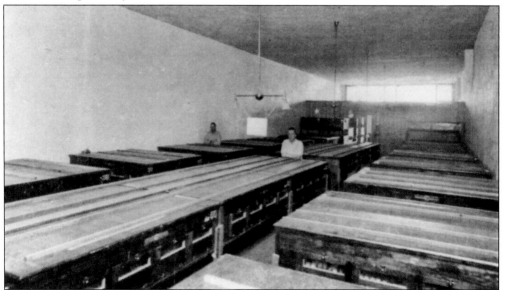

CHICKEN HATCHERY, 1920s. Every home in Escondido had a flock of chickens to keep the family fed. Raising chickens became big business, originally beginning as a home industry and swelling into a profitable industry as the demand for hatchlings grew with Escondido's population. Hatcheries were lucrative businesses well into the 1930s and, as seen in this interior image of incubators by Havens, quite technologically advanced for the era. (Courtesy EHC.)

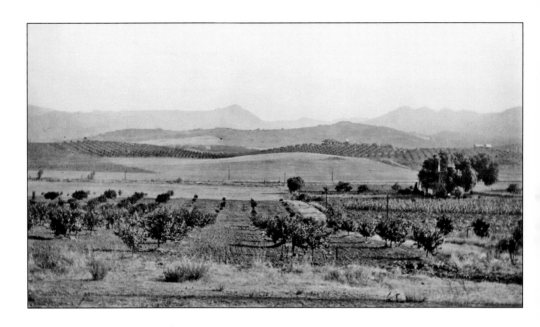

EARLY ESCONDIDO FARMING AND RANCHING, 1911–1920. Orchard management and dry farming on Escondido's town outskirts were in full production between 1911 and 1920 as seen in these two panoramas by Havens. Young apricots with fledgling oranges in the distance dot the rolling hillsides at the W. E. Alexander Orchard near Bear Valley Road. Below, Wolfskill Ranch in 1920 was a prime location for dry farming as freshly sprouting fodder and cut haystacks abound. (Courtesy PR.)

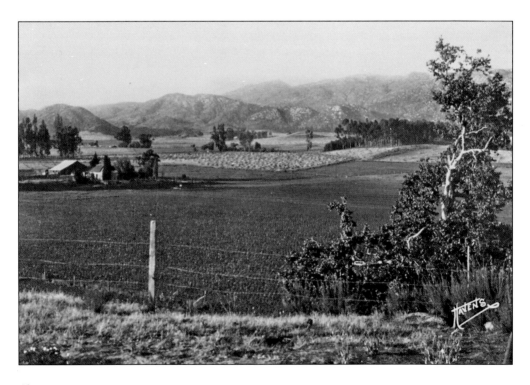

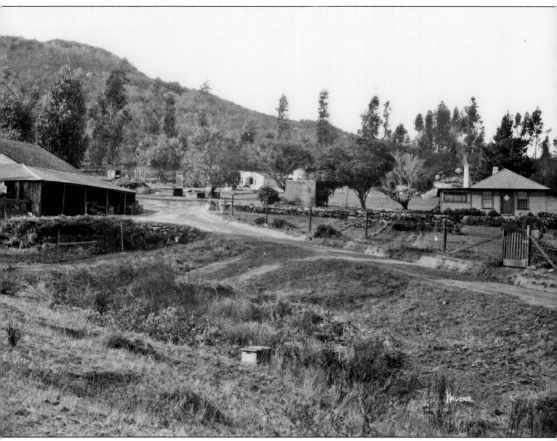

EARLY-DAY ESCONDIDO RANCH, 1915. This ranch in the vicinity of San Pasqual Valley, southeast of Escondido, typifies the style of living that families led on the outskirts of town in the early 1900s. Self-sustenance was necessary, as making the trip into town for groceries was not readily possible compared to today's conveniences. Instead of garages for cars and grocery stores, there were barns for horses, gardens for food, orchards for fruit, and beehives for honey.

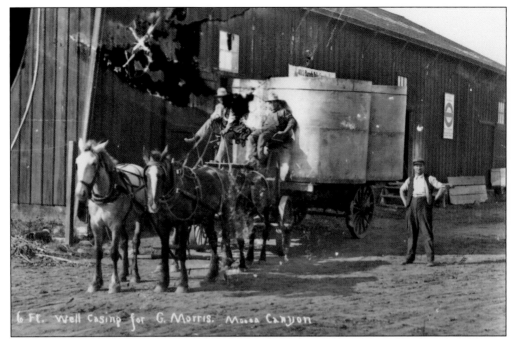

6 Ft. Well Casing for G. Morris. Moosa Canyon

WATER EQUIPMENT MANUFACTURING, 1914. In addition to the major construction of flumes, dams, and reservoirs, enterprising Escondidans needed to create a significant infrastructure of pipes and wells for bringing the water they needed to their crops. An old and shattered glass negative from 1914 by Havens depicts shipping day of a six-foot metal well casing made for G. Morris in Moosa Canyon, north of Escondido by the Valley Sheet Metal Works. Below, the Escondido Mutual Water Company's bone yard of concrete pipes lies in storage behind the Escondido Hotel on Valley Boulevard awaiting shipment for installations. (Courtesy PR.)

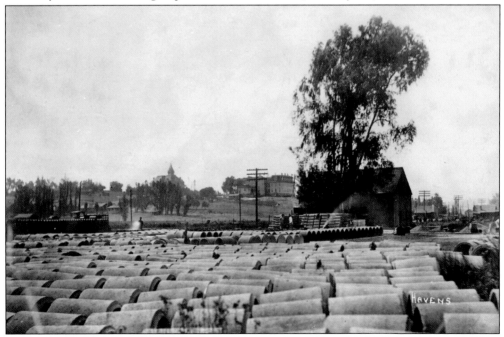

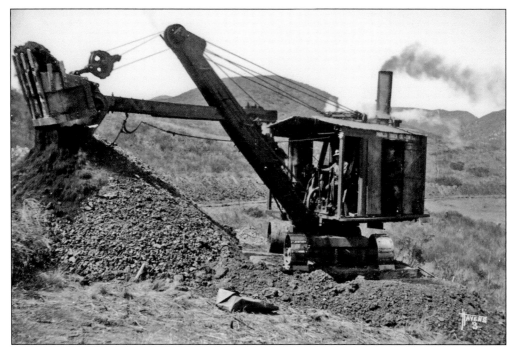

VISTA FLUME CONSTRUCTION, 1925. Both the Escondido Mutual Water Company and the Vista Irrigation District collaborated in 1923 to share irrigation water from the Upper San Luis Rey Watershed. Transported from Bear Valley Dam to Vista by a newly constructed flume, water was brought 10 miles to Buena Creek's Pechstein Reservoir. The use of both hand labor and a diesel steam shovel from the Pioneer Truck Company, modern technology for the era, enabled the crews to move efficiently to construct the lifeline. (Courtesy EHC.)

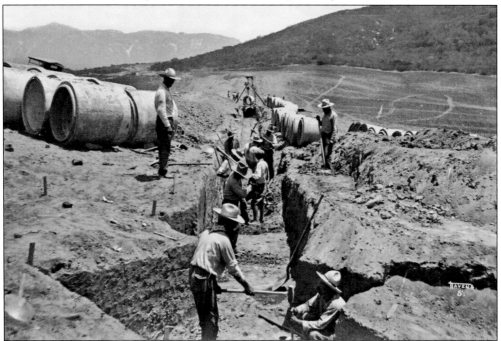

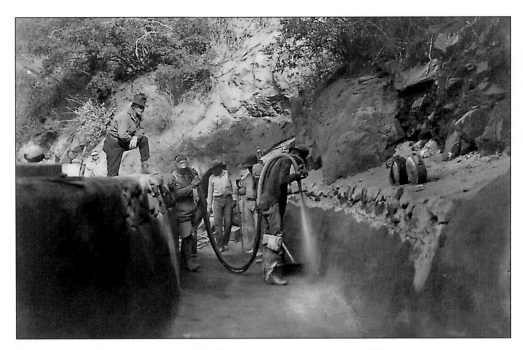

VISTA FLUME CONSTRUCTION, 1925. These images Havens shot in 1925 depict the construction crews finishing the interior surface of the hand-dug ditch with concrete gunnite. The sprayed material shored up the sides and bottom of the ditch and allowed for erosion-free transportation of water, as seen in the below image. A maintenance track persisted for some years after construction for inspections. (Courtesy EHC.)

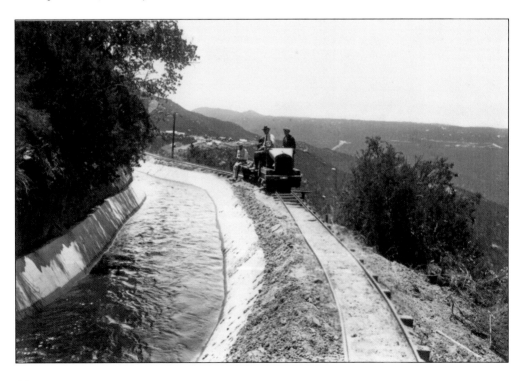

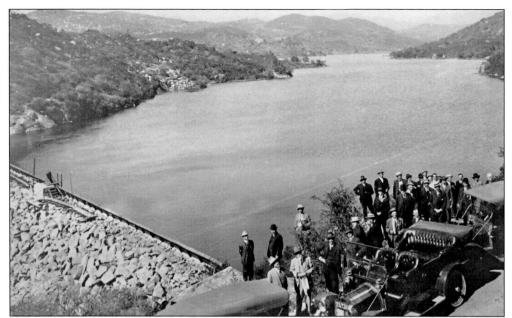

BEAR VALLEY DAM, 1911. Citrus, grapes, and town growth created a growing burden on the already limited water supply. Valley wells delivered meager supplies from their conception; therefore, in 1894, as part of 15 miles of ditches from Upper San Luis Rey Watershed, the Escondido Mutual Water Company built Bear Valley Dam, later named Lake Wohlford. The granite and earthen fill dam was strengthened and raised in 1923 by hydraulic mining for increased capacity. (Courtesy EHC.)

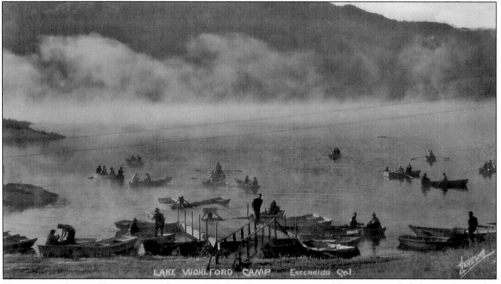

KUEBLER'S LAKE WOHLFORD CAMP, 1920S. Campers enjoyed boating and fishing along the north shore of Lake Wohlford at Kuebler's Camp. Havens conducted photo shoots in the 1920s to promote business. Minnie and Charlie Kuebler opened the campground on their ranch in 1927. Two years later, the Escondido Mutual Water Company opened the lake to fishing and hired Charlie as caretaker, a job he held for 20 years. Lake Wohlford Resort now occupies the location of the historic camp. (Courtesy EHC.)

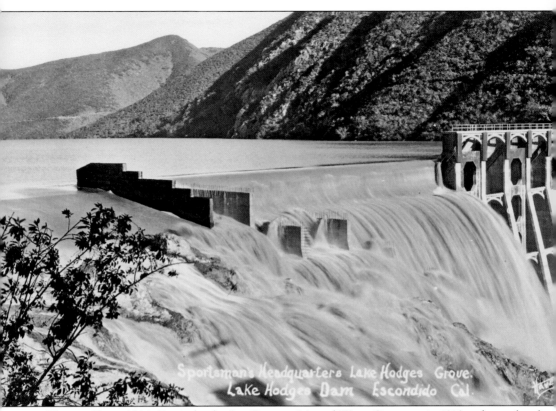

Sportsman's Headquarters Lake Hodges Grove.
Lake Hodges Dam Escondido Cal.

HODGES DAM, 1920. Begun by the San Dieguito Mutual Water Company in 1918 and completed in 1920, the Hodges Dam was constructed to deliver water to the lower San Dieguito Valley and Rancho Santa Fe. Located on the southwest side of Escondido near Del Dios, it was named after a vice president of the Santa Fe Railroad who made the necessary financing for the $630,000 construction. The dam consisted of 23 reinforced concrete buttress arches spanning 24 feet in width and 133 feet in height. The dam was found cracking shortly after construction, and no action was taken to reinforce the structure, yet shortly after the 1933 Long Beach earthquake, retrofitting was made by 1937. The lake is filled to capacity in this 1920 image by Havens and quickly became a popular location for fishing and sportsmen's activities. (Courtesy PR.)

Four

BUSINESS, RELIGION, AND INDUSTRY
WORKING, PRAYING, AND PRODUCING

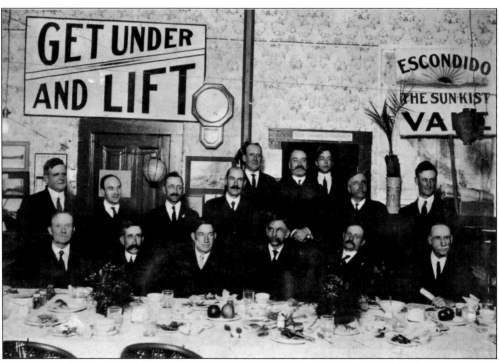

ESCONDIDO CHAMBER OF COMMERCE, 1914. The chamber strove to fulfill their motto of "Get Under and Lift" as this gathering of the boosters of the Sunkist Vale depicts. Directors worked to publicize Escondido against financially competing cities, such as Riverside and Anaheim, for business exposure. From left to right are (first row) W. H. Baldridge, David Oaks, E. J. Lovelace, Arthur Jones, W. N. Bradbury, and W. L. Ramey; (second row) Russell Cox, A. J. Rutherford, J. V. Larzalere, Edgar Buell, W. E. Alexander, G. W. Wisdom, E. E. Ford, Jim Heath, and Percy Evans. (Courtesy PR.)

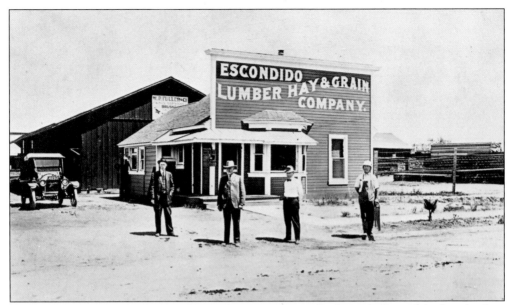

ESCONDIDO LUMBER, HAY, AND GRAIN COMPANY, 1911. In the early Escondido days, lumber, hay, and grain were staples of industry, development, and sustenance. In this 1911 photograph, Escondido Lumber, Hay, and Grain is shown in its daily business as a source of all the building materials, feed, and livestock trade and sales in the region. Sacked grain and baled hay hauled to the ELH&G Company were eventually shipped to cattlemen everywhere. Photographed inside the ELH&G office are, from left to right, owners G. V. Thomas and W. L. Ramey and bookkeeper Howard Turrentine. Note the fine adding machine and, in contrast, the pool of tobacco spit near the wastebasket and on the wall. (Courtesy PR.)

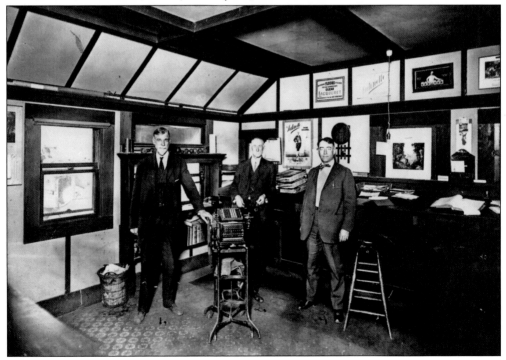

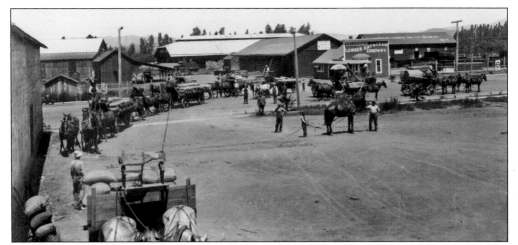

ESCONDIDO LUMBER, HAY, AND GRAIN YARD, 1911. The queue of wagons in the photograph at the Escondido Lumber, Hay, and Grain Company was a regular sight as locals converged on the yard to deliver grain to market, which was sold out from there, and also to load deliveries to outbound locations. The man in the center to the left of the small palm tree can be seen posing with his horse on page 104.

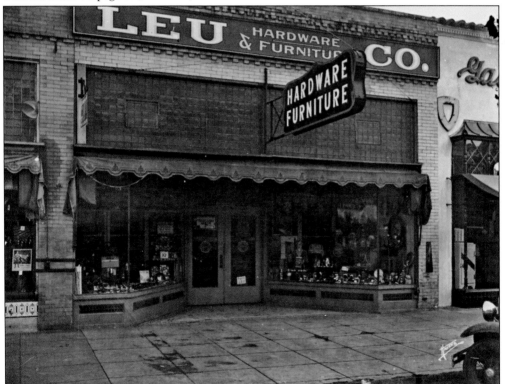

LOCAL HARDWARE. In the days before big-box hardware, a friendly mom-and-pop-style hardware store was where everyone went for their home or businesses. From furniture to fixtures, clothing to seeds and paint, Leu's had it all. Havens was often commissioned to photograph storefronts for business owners, yet he had a passion for architecture and buildings himself and often photographed these locations for his own reference in future building projects in town. (Courtesy EHC.)

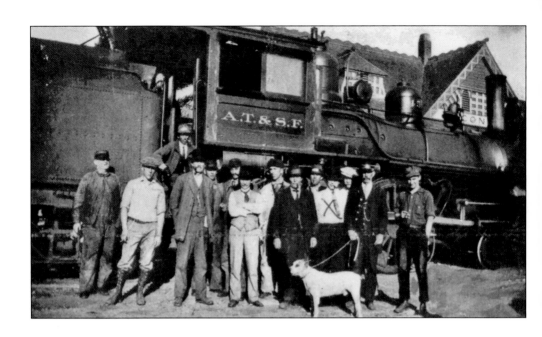

ESCONDIDO SANTA FE RAILROAD, 1916. Boasting a proud moment on February 17, 1916, in the aftermath of the 1916 winter floods that rendered the rails useless, the Escondido crew of the Santa Fe Railroad poses for a photograph after bringing a double-engined freight line of cars into Escondido along with empty freight cars to catch up on delayed fruit shipping. The men were banqueted with a feast, and the mascot dog, Fargo, got a big bone as a reward for reestablishing the lifeline link to the outside world. Crew members below, W. W. Carpenter (second from left) and Carl Ashleigh (far right), posed in front of an ice bunker reefer car for shipping citrus to Eastern markets. (Courtesy PR.)

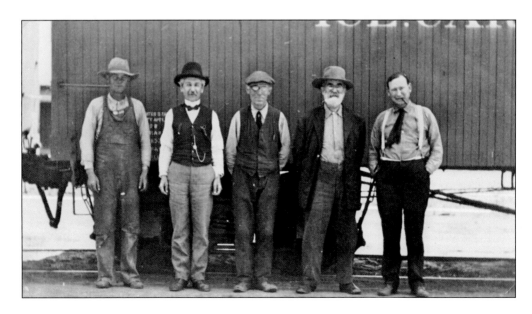

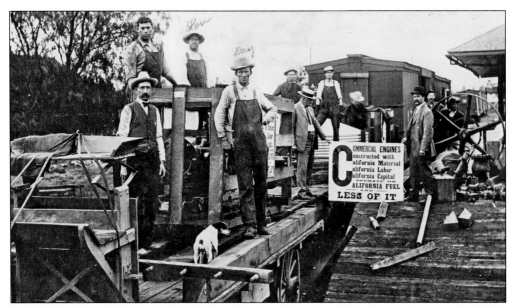

CALIFORNIA FREIGHT INDUSTRY, 1913. Another shipment of freight arrives around 1913 by Santa Fe Railroad to Escondido to enrich life and better industry. The men have just finished transferring crated machinery from the railcar to the horse-drawn wagon for transport to a new hydroelectric power plant at Bear Valley Dam. The power company obviously engaged in a political statement via Havens's photography, supporting local industry by selecting equipment that is California manufactured. The dog seems quite supportive taking in the scene resting behind the driver's seat. (Courtesy PR.)

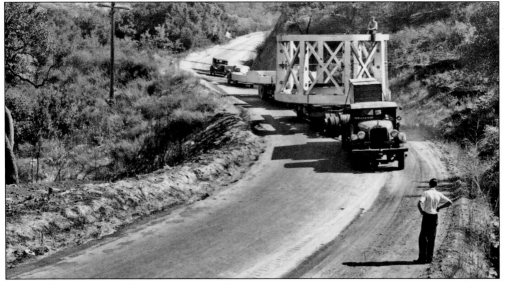

HALE TELESCOPE TRANSPORTATION, 1938. Caltech's famous 200-inch Hale Telescope, located on Mount Palomar directly east of Escondido, has been an iconic part of Escondido's history since the 1930s. The prime focus cage for the telescope arrived in San Diego by steamship from Philadelphia in October 1938 and was trailered through Escondido on the "Highway to the Stars," today known as State Route 6 or Valley Parkway, with a chain of onlookers following. (Courtesy EHC.)

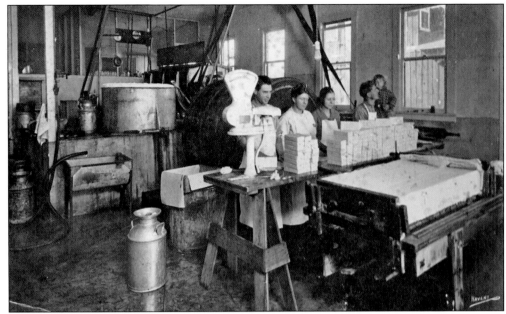

ESCONDIDO CREAMERY, 1912. Inside the Escondido Creamery in 1912, workers would separate the milk layers of cream into butter as seen in this early Havens photograph. Local dairymen would bring their excess milk production to the creamery and in exchange obtain a credit for products or cream check (a voucher) to deposit. In the background, separating machinery stands ready, while in front, stacks of butter and a forming box with top skimmer is present. (Courtesy EHC.)

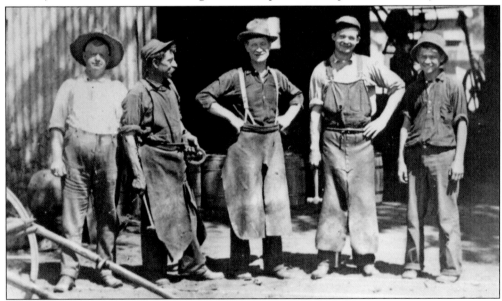

BANDY BLACKSMITH SHOP, 1914. The Bandy Blacksmith Shop, perhaps one of only a few in California to offer traditional full-service smithing services, persisted as an Escondido business for almost 80 years at Valley Parkway and Kalmia Street. The focus of its work was on carriage and farm implement repair in the early days, with ornamental ironwork in latter days. Pictured are, from left to right, John Brooks having his horse shod, shoer Marianna Duarte, owner Tom Bandy, an unidentified assistant, and Tom Bandy Jr. (Courtesy PR.)

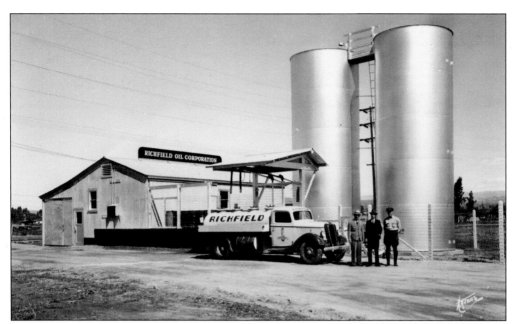

RICHFIELD OIL COMPANY, 1935. The Richfield Oil Company of California had holdings in a transfer and stock station in west Escondido in the late 1930s for supplying stations locally. Richfield Oil, a Depression victim in 1936, was operated by a federal court-appointed receiver in the days of its downfall but was acquired by the Atlantic Refining Company and combined in name to become Atlantic Richfield Company, or ARCO. (Courtesy EHC.)

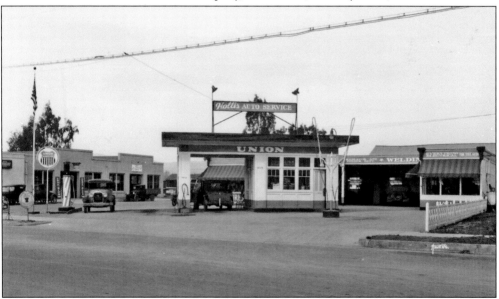

HOLLIS AUTO SERVICE, 1930S. Today where service stations are no longer incorporating service into their offerings, Havens imagery proves differently of the past. James Hollis constructed one of the first full-service filling stations on the corner of Lime Street and Ohio Avenue (now Broadway and Valley Parkway) in the 1920s. This station offered complete service and Union fuel, with electrical, tires, brakes, fender, and body repairs and welding, quite the one-stop repair shop for locals. (Courtesy EHC.)

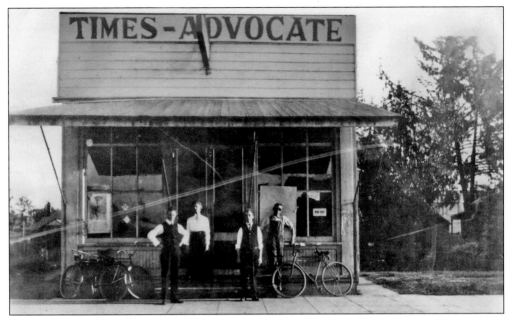

ESCONDIDO *TIMES-ADVOCATE*, 1918. The *Escondido Times*, founded 1886, and the *Advocate*, founded 1891, merged into the *Times-Advocate* in 1909, forming one of the longest-standing institutions in Escondido history. The *Times-Advocate* became a daily newspaper with much credit given to owner/editor Percy Evans. It was instrumental in featuring local facets of early growth, news, and social happenings while today acting as a relic document of Escondido's history. Above, the exterior of the *Times-Advocate* in 1918 was captured by Havens with news of the end of World War I posted in their window. From left to right, Percy Evans, Lucy Turrentine, and Aubrey Ashley stand at front. Below, inside the pressroom, stand, from left to right, Brown McPherson, Lucy Turrentine, Aubrey Ashley, and Percy Evans. (Courtesy PR.)

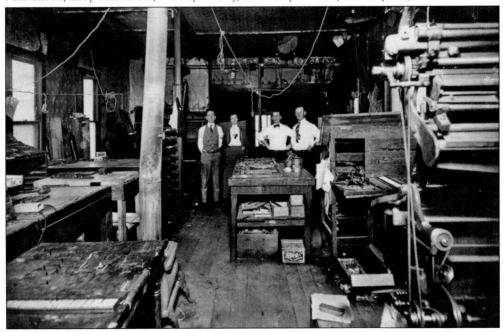

KINEMA THEATRE, 1929. The Kinema Theatre opened its doors at 200 East Grand Avenue on December 23, 1920, and entertained Escondidans with the Douglas Fairbanks movie *The Mark of Zorro.* It also hosted Escondido's first sound-scored motion pictures in 1929 along with many community gatherings, plays, and graduation ceremonies. It changed hands in 1931 and was renamed the Pala Theatre, which again changed hands and eventually was converted to the eight-lane Pala Bowl bowling alley in the 1950s. A common sight around town was their mascot. (Courtesy EHC.)

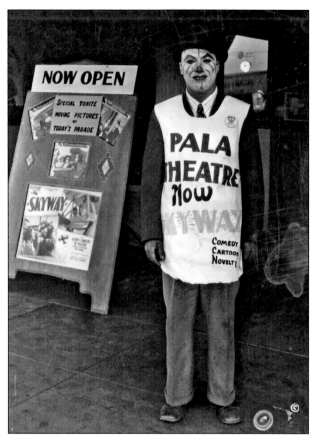

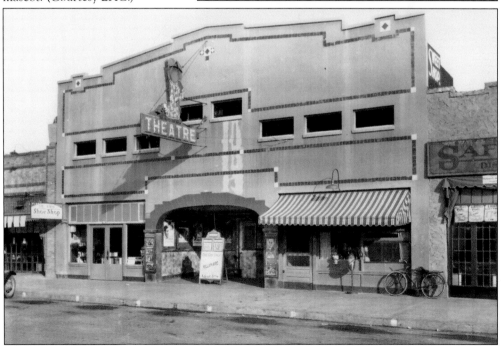

ESCONDIDO HOSPITAL, 1920S. In the 1920s, doctors Dotson, Kemper, and Ridley and surgeons J. V. and R. V. Larzalere opened Escondido's first hospital-clinic at 145 West Grand Avenue. Later when R. V. B. Lincoln Hatchery closed doors on South Broadway Avenue, the doctors moved in, turning the poultry building into professional offices. Seen here, Dr. Ray Larzalere (left) and osteopath Dr. C. J. Ridley stand in the doorway to their offices for Havens in a photo postcard shoot. (Courtesy PR.)

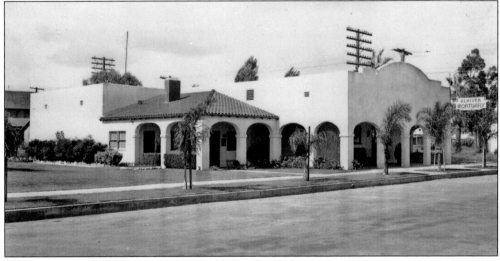

ALHEISER-WILSON MORTUARY, 1930S. The Alheiser-Wilson Mortuary, as seen in the 1930s on Broadway and Iowa Avenue (now Third Avenue), is one of Escondido's longest continually operating businesses at the same location. Established in 1897, the mortuary was originally opened by F. G. Thompson, funeral director. Despite changing hands several times over the years and many modifications to the structure's facade, the business continues to retain its service to the community. (Courtesy EHC.)

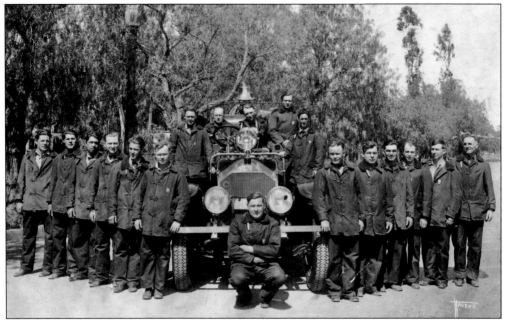

ESCONDIDO VOLUNTEERS, 1925, AND 1940 FIRE DEPARTMENT. A new American LaFrance pumper truck, with the nickname "Betsy," was a proud showoff with her fiery red paint in the volunteer firefighters photograph above in 1925. Adorned with her shiny brass bell and search light, fire extinguishers, and various other pieces of equipment, Betsy was a fine example of the cutting-edge fire apparatus technology for the times. Betsy, however, failed her first major assignment in 1929 as an overheated timing gear rendered her helpless in fighting the Escondido High School fire. Photographed below, Chief Karl Petersen and assistants Al Bandy and Dick Geisbright stand in front of the Works Progress Administration–built firehouse. (Above, courtesy PR; below, courtesy EHC.)

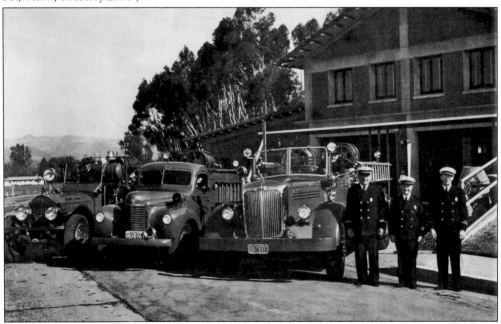

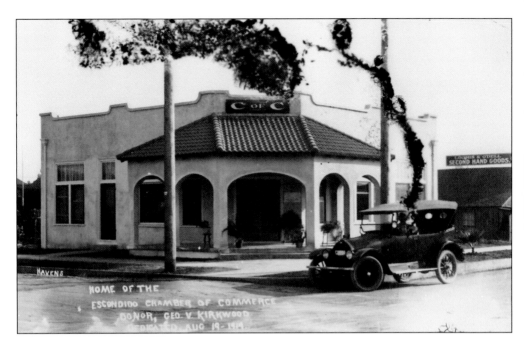

ESCONDIDO CIVIC BUILDINGS, 1919 AND 1938. The Escondido Chamber of Commerce and Escondido City Hall both shared classic versions of California mission style architecture as the Escondido chamber in 1919 sports a fresh coat of stucco in this well-weathered Havens image. Constructed by the WPA, the Escondido City Hall with its thick adobe walls was built in 1938 on Hotel Hill at the top of Grand Avenue. The adobe structure initially housed city offices and later the Escondido Police and Fire Departments, as seen on the previous page. It was demolished in the 1980s to make way for Palomar Hospital's expansion. (Below, courtesy EHC.)

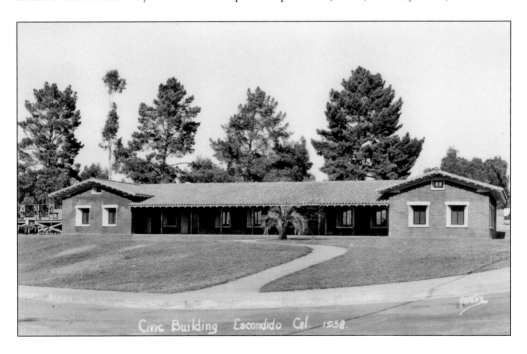

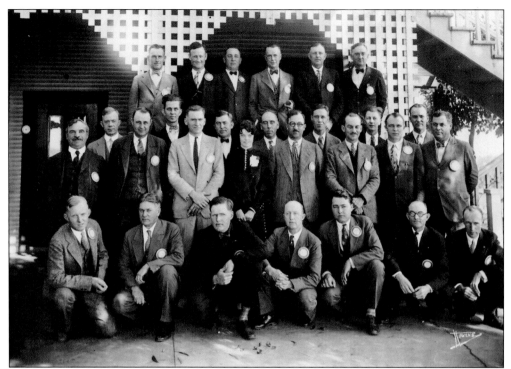

ESCONDIDO ROTARY CLUB, 1927. In 1927, the Escondido Rotary Club celebrated 100-percent attendance for two years with an elaborate party at the Escondido Country Club. Post-dinner and program, dancing accompanied the popular county music entourage the George Wessels Orchestra. Havens was an active member of the Rotary, yet it is uncertain if he is behind the lens or sitting fourth from left at front. (Courtesy EHC.)

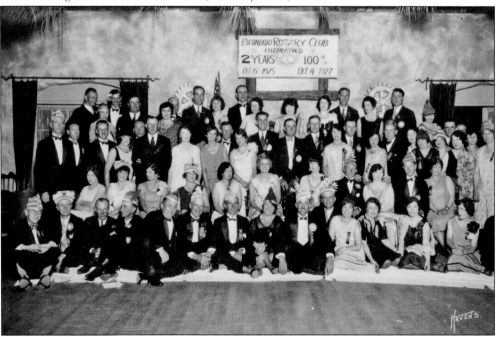

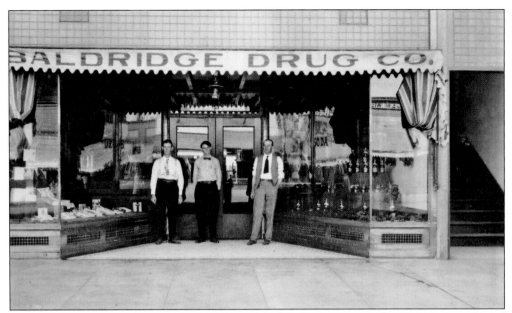

BALDRIDGE DRUG COMPANY, 1911. W. H. Baldridge, druggist, opened a fine store on Grand Avenue in 1910 and commissioned Havens to conduct interior and exterior shots after Havens Studio commenced business in early 1911. Baldridge had renovated the existing Roger Drug Store facility and added a fanciful soda fountain and interior decoration, which became the talk of the town for visitors to have "sweets with their sweet." (Courtesy PR.)

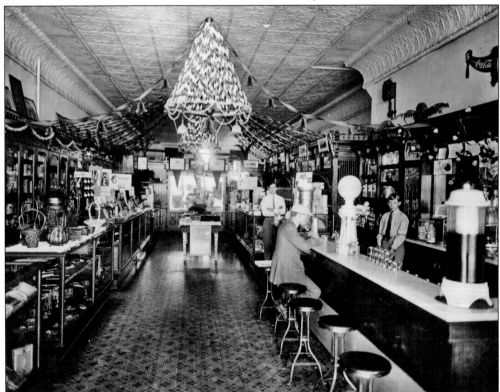

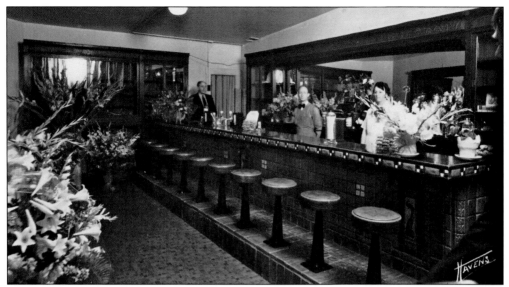

PALA SWEETSHOP INTERIOR, 1932. The Pala Sweetshop was a favorite hangout for the local young crowd in the 1930s. Adjacent to the Pala Theatre on Grand Avenue, the shop was always a gathering place to socialize, see, and be seen. The fancy deco tile work on the counter and floors gave the place a contemporary appearance. (Courtesy EHC.)

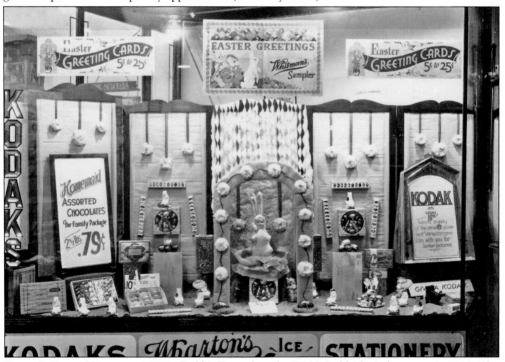

ROLFE'S DRUG WINDOW, 1930S. Rolfe's Drugs bought W. H. Baldridge's drugstore in 1913. The store always had wonderful displays from shelf to ceiling behind the plate glass. Obviously Havens had competition for film sales as this 1930s Easter season window implies, yet Rolfe's maintained its popularity with the old soda fountain and other supplies and notions it sold, especially during holidays. (Courtesy EHC.)

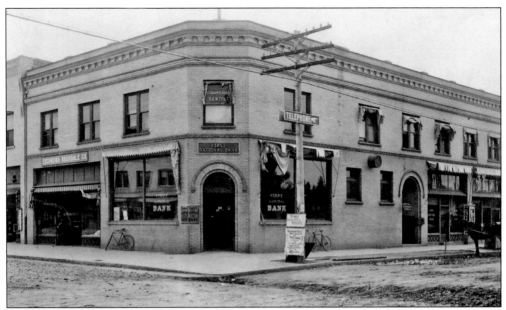

FIRST NATIONAL BANK, 1913. A long-vacant lot at the southeast corner of Broadway and Grand Avenue went through a growth spurt in 1905 with a new building housing the First National Bank. Prior to its incorporation, banks came and went in Escondido with the times and their growth booms and busts, yet First National Bank came in strong and eventually changed hands to Southern Trust and Commerce Bank in 1924. (Courtesy PR.)

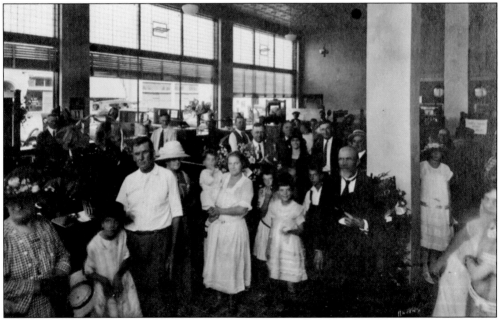

SAN DIEGO COUNTY NATIONAL BANK OPENING DAY, 1923. The San Diego County National Bank opened its doors to the community on August 11, 1923, from the ground floor of the old Steiner and Company General Merchandise Building on the southwest corner of Grand Avenue and Lime Street (Broadway). Openings of businesses in the community always were public events worthy of capturing the crowd in attendance by Havens's lens. (Courtesy EHC.)

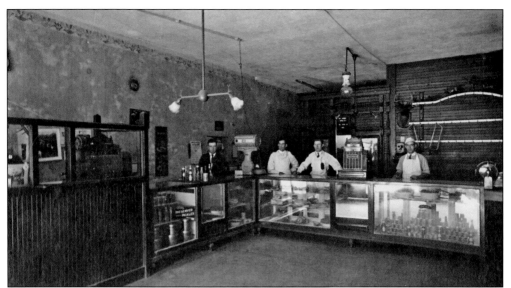

INSIDE PIONEER MEAT MARKET, 1922. The Pioneer Meat Market, under the ownership of Louie Cassou, was Escondido's first butcher shop and one of the earliest stores on Grand Avenue, opening shortly after the city's incorporation in 1888. The business persisted through a move of the entire building to a new location and its later reestablishment on the ground floor of a hotel building. Havens captures the 1922 store interior with its glass cases of meat and Heinz products. (Courtesy EHC.)

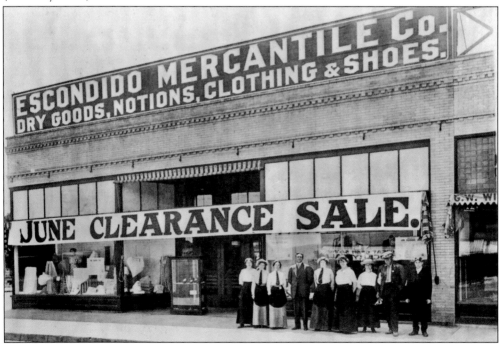

ESCONDIDO MERCANTILE, 1912. Staff of the Escondido Mercantile Company, one of the longest-standing family businesses in Escondido, stands outside on June clearance opening day in 1912 for Havens. Prior to its opening in 1905, Escondido never had a store offering such a variety of men's and women's clothing and goods under one roof. (Courtesy PR.)

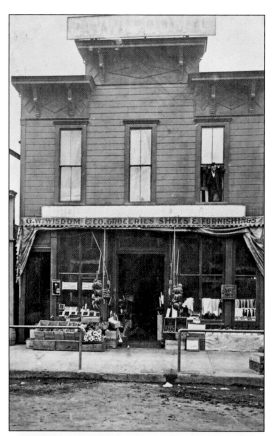

G. W. Wisdom Grocery Exterior and Interior, 1911. G. W. Wisdom Grocery opened for business in 1904 and continued at various locations on Grand Avenue until finally selling to Shelby's Grocery in 1924. The store was an early institution in Escondido as it offered, along with all the basics, shoes, some clothing, and furnishings for the home. Guy Wisdom was active on the Grape Day board and stood as an iconic figure in Escondido's business and civic development. This 1911 exterior shot of the original 1904 store along with an interior shot were commissioned by Havens for Wisdom's business development. (Courtesy PR.)

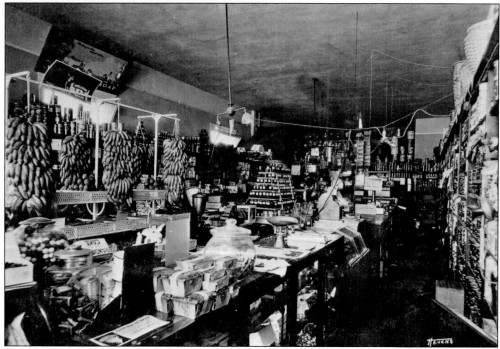

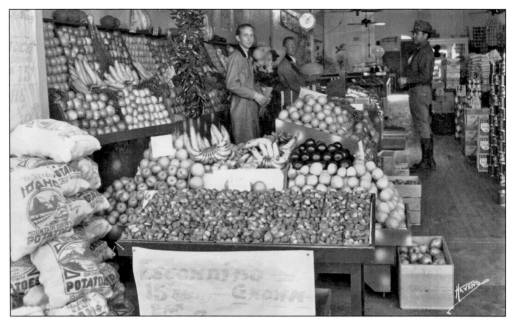

EARLY-DAY GROCERY STORE, 1930. Early grocery stores had a habit of being short-lived in existence, as they would open, remain in business for a few years, then change ownership or close their doors. However, one commonality of Escondido stores through the years was the quality of personality, service, and stock that local stores maintained. The Busy Bee Grocery on Lime Street and Ohio Avenue (Broadway and Valley Parkway) was one such store, with a fine stock and service in this crisply detailed Havens photograph. (Courtesy PR.)

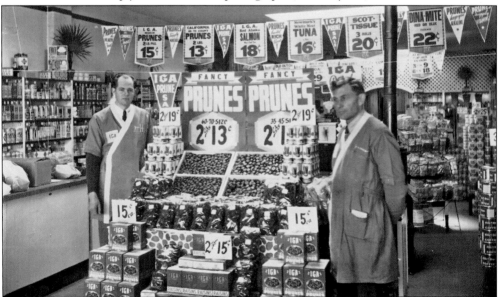

IGA GROCERY DISPLAY—KEEPING REGULARITY, 1930S. The IGA grocery store had a unique display for Havens to photograph in the 1930s, as they were obviously promoting a glutton of stock in prunes. It should be well known, per the banner above the clerk, that customers could rest easy knowing that they could find a bargain on toilet tissue to accompany their prune purchase. (Courtesy EHC.)

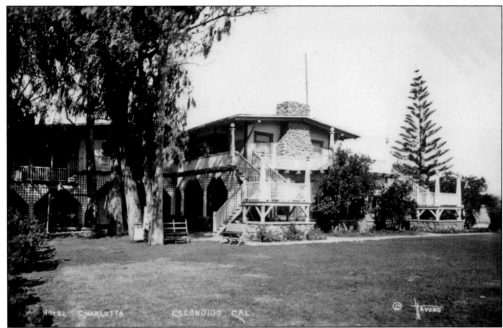

HOTEL CHARLOTTA, 1920S. In the early days of Escondido, visitors would be accommodated in the Escondido Land and Town Company's Escondido Hotel, which was the chosen standard accommodation for guests, visitors, and dignitaries. In later years, with the coming of the automobile, the hotel's popularity waned in the shadow of the modern Hotel Charlotta, which offered party, banquet, dining, and dancing opportunities to the tie-and-tails Escondidans. Built in 1915 by Harry J. Schrupp, the craftsman bungalow facility was named for his daughter Charlotte. The hotel's interiors offered cozy furnishings, and its exterior offered an expansive 30-acre garden setting on a westerly hill with wonderful eastward views. It stands today on South Upas Street at Charlotta Heights. (Courtesy EHC.)

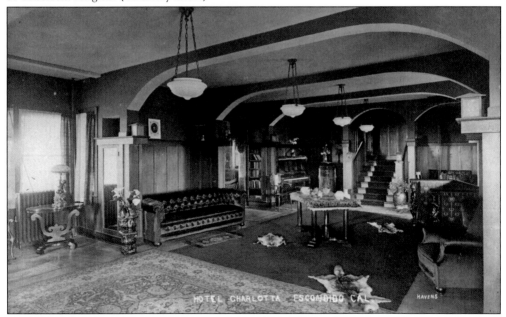

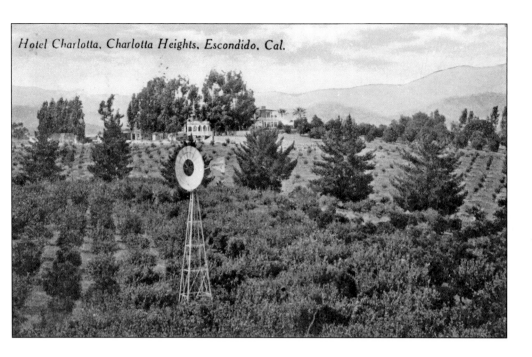

Hotel Charlotta, Charlotta Heights, Escondido, Cal.

EARLY HOTEL POSTCARDS. Havens was commissioned quite regularly by local businesses to photograph interior and exterior scenes for advertising purposes. Many of these images made it into chamber of commerce publications or newspaper advertisements or on postcards sold locally to promote to persons elsewhere. The Hotel Escondido and Hotel Charlotta both had Havens do such commissions, and uniquely each postcard was "brushed" with color and tone to hide blemishes and make it fancy. (Courtesy R. Dotson.)

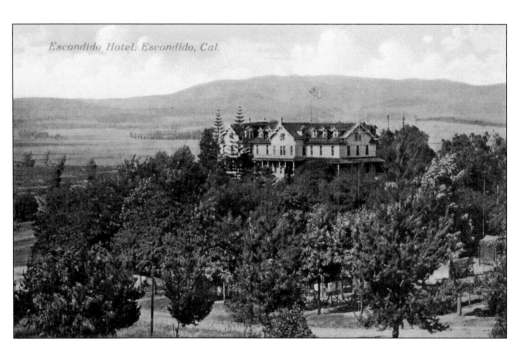

Escondido Hotel, Escondido, Cal.

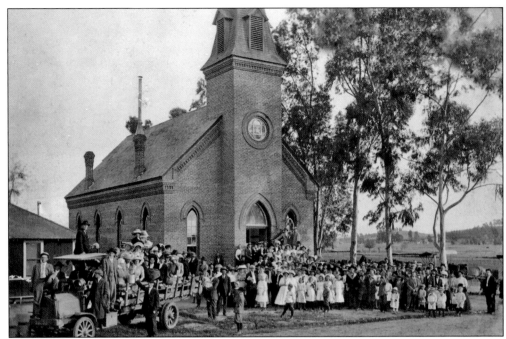

Seventh-Day Adventist Church Celebration, 1914. A gathering of over 300 attendees grouped together at the old Southern Methodist church in 1914 for a conference of San Diego County Adventists. One of the seven original churches granted land by the EL&T Company, this structure was constructed in 1887 and was sold in 1900 to the Seventh-day Adventist church. It was one of Haven's favorite structures to photograph and stands today at Fourth Avenue and Orange Street. (Courtesy PR.)

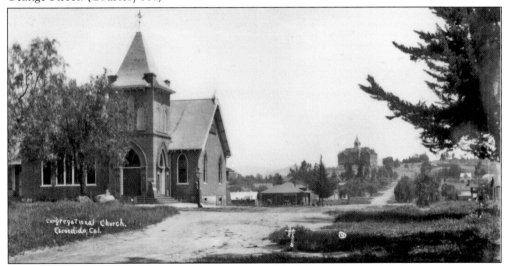

Congregational Church, 1916. The original Congregationalists started with a one-wing church building at Iowa and Maple Streets in 1888 and added to the structure until the floor plan in the shape of a crucifix was completed for a grand dedication in 1898. At their cornerstone dedication on Sunday, January 2, 1898, Congregationalists placed various pieces of memorabilia to commemorate the new facility. Old Escondido High school can be seen in the distance to the east.

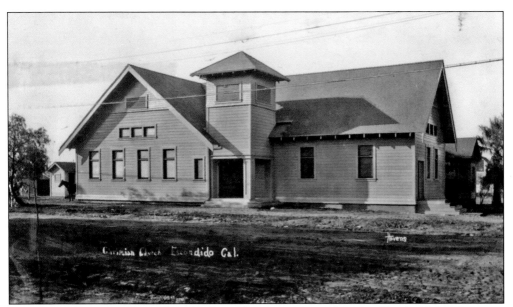

CHRISTIAN CHURCH, 1912. The Christian Church was granted free land by the EL&T Company to construct on Lime Street (Broadway) in 1890. Interested in growth, they traded the free land for a corner lot on what is now Second Avenue and Juniper Street. They built a unique new structure by group help. The gray wooden church was an oddity in the town of red brick, yet in 1912, members had something to be proud of at an opening service of 350 Escondidans. (Courtesy PR.)

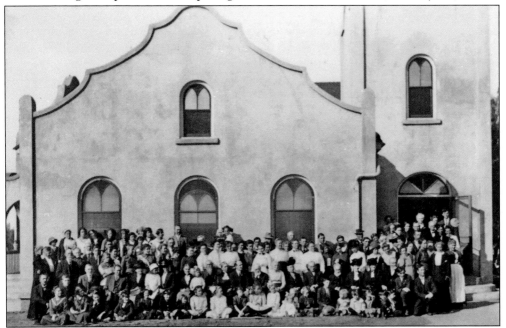

FIRST BAPTIST CHURCH, 1913. The First Baptist Church on Fifth and Kalmia Streets is depicted on an all-day meeting of parishioners on January 1, 1913. This second facility, built in the mission revival style in 1910, was preceded by a one-room, red-brick building constructed in 1887 on Curve Street, now Ivy, below the USC Seminary. A fantastic rose garden kept by parishioners regularly sweetened the air of the Sunday congregational services. (Courtesy PR.)

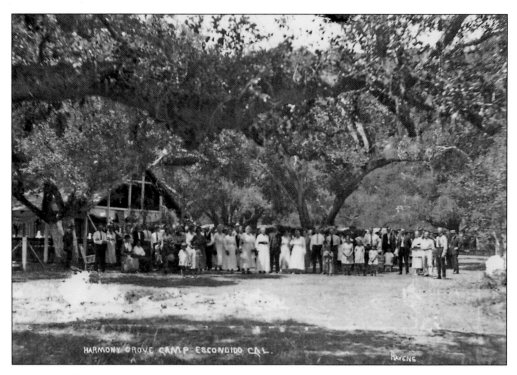

HARMONY GROVE SPIRITUALIST ASSOCIATION, 1916. Harmony Grove, along Escondido Creek west of town, has always been a gathering spot for locals since the early days. In 1896, the Harmony Grove Spiritualist Association incorporated a camp and fellowship hall offering summer camp seasons to which Escondidans flocked to learn spiritualism and spend summer days. Havens shot a series of images over the years of the camp, events, and surroundings under grand oaks.

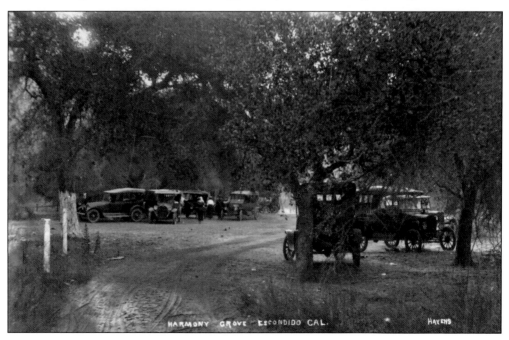

Five

GRAPE DAYS
AN ESCONDIDO TRADITION

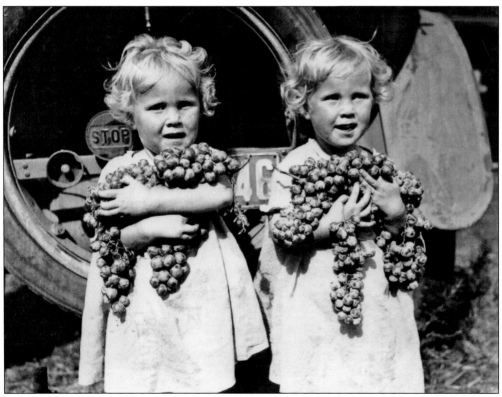

GRAPE DAY GIRLS, 1930. Two unidentified girls in 1930 pose with bunches of muscats at the post–Grape Day Parade gathering in Grape Day Park. The highlight for many children growing up in Escondido was the festivities where grapes were given out each year. Waiting lines formed in the park at the grape stand while visitors were helped to the delicious treats. Every man, woman, and child became a grape admirer thanks to Grape Day. Grapes over the years became the iconic and agricultural symbol of the event because of the popularity of giving them away. (Courtesy PR.)

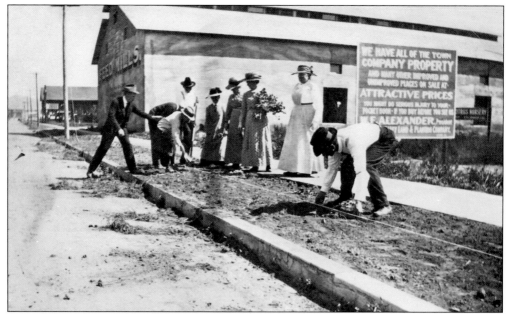

SPRUCING UP GRAND AVENUE FOR GRAPE DAY, 1914. Escondidans took a lot of pride in making sure their city was presentable for annual Grape Day festivals. Volunteer crews would gather in advance to tidy up the main avenue, festooning it with flags and bunting, cleaning weeds and debris, and decking it out with decorations to impress the arriving guests. The Floral Society added Washingtonia palms along the curbs flanking Grand Avenue in 1914, seen here being laid out with a string in the parkway. (Courtesy PR.)

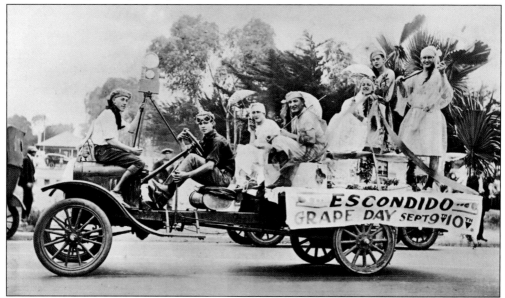

GRAPE DAY BOYS, 1923. The 1923 Grape Day boys advertising around San Diego County were in such anticipation of popular movie star Agnes Ayers becoming the Grape Day queen for the year that they set forth rigged in a movie set on wheels, imitating the coming event. They toured nearby communities promoting the Grape Day festivities, gaining many laughs from their comical act. (Courtesy PR.)

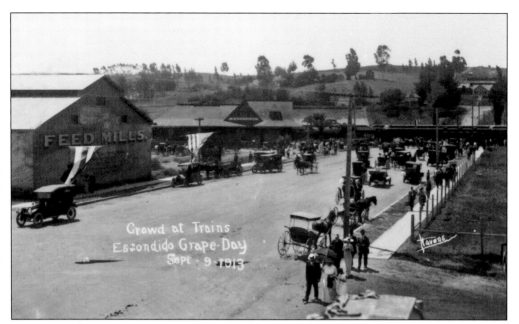

GRAPE DAY SPECIAL TRAIN, 1913. A "special train" every Grape Day brought curious strangers who stepped off coaches and were greeted by friendly townsfolk. The hospitality of Escondido with its charming schools, ranches, churches, homes, clean air, warm climate, and family atmosphere paid a friendly welcome. Special trains were significant occasions in early days, with fares of $1.50 round-trip from San Diego and $3 from Los Angeles bringing hundreds for special events.

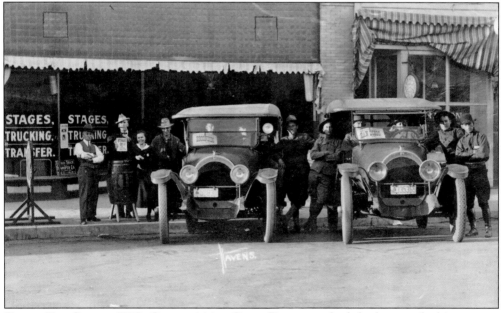

GRAPE DAY STAGE, 1918. Guests visiting Grape Day events had the luxury of taking a stage up Grand Avenue from the Santa Fe Depot and to and from destinations in San Diego, as seen in the window placards on the Grape Day Stage. Soldiers stationed locally during World War I offered the escorted rides as part of an independent business assisting the Grape Day Association. (Courtesy PR.)

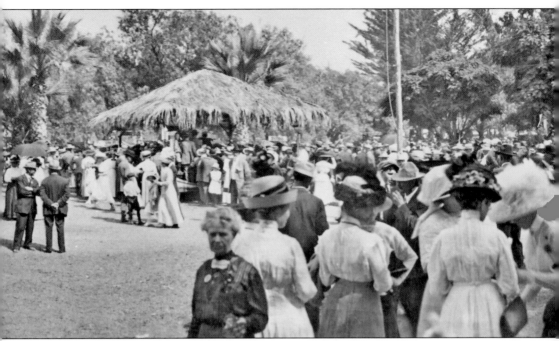

GRAPE DAY PARK, 1913. Grape Days in 1908 and 1909 were held on Grand Avenue and vacant lots on Maple Street, under arbors of palm thatched with purple and green grapes. The 1910 celebration changed to the old site of Lime Street School, current site of Grape Day Park, creating

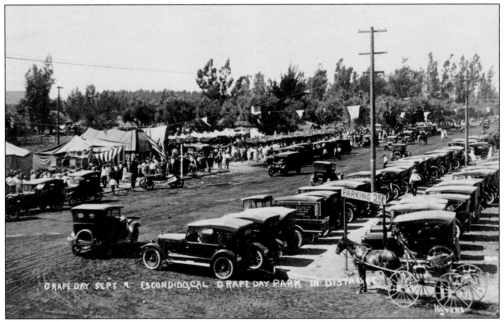

GRAPE DAY AFTERNOON, 1913. Lines never ceased to exist at Grape Day events, including parking, as in this 1913 image along Lime Street (Broadway) at Ohio (Valley Parkway). With the gaining popularity of both visitors and the more affordable automobile, property owners took full advantage of vacant lots to capitalize on profits. In the distance, the sprawling food tents and displays of the post-parade events in the park are crowded with patrons. (Courtesy EHC.)

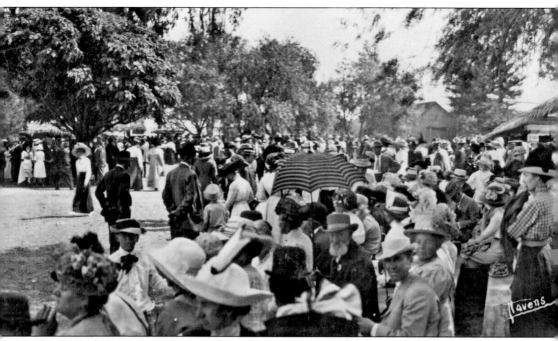

a tradition. Each Grape Day, throngs of people dispersed from the parade to the various events in the park, viewing displays, eating grand picnics, watching races, and listening to speeches, music, and pioneers. (Courtesy PR.)

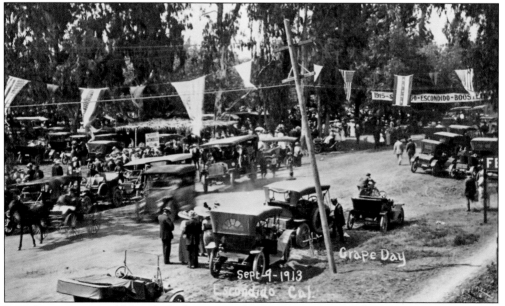

LIME STREET, 1913. Although the banner reads "San Diego–Escondido Boosters 1915," Havens's etching on the glass negative shows the date as Grape Day 1913. The view down Lime Street, adjacent to Grape Day Park, is bustling with horses and horseless carriages as folks hurry to get prepared for the forthcoming parade festivities on Grand Avenue. This image was produced as a photo postcard, with the telephone pole and other obstacles removed, all in a day before modern digital photograph altering. (Courtesy EHC.)

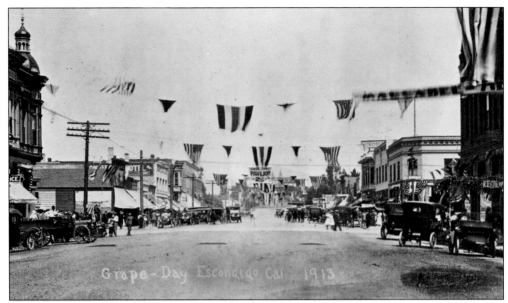

GRAND AVENUE GRAPE DAY, 1913. The pre-parade view east on Grand Avenue captured by Havens from Lime Street towards Hotel Escondido depicts the energy of preparation put forth by Escondidans for the festival. Each Grape Day, the streets were spic and span and adorned with patriotic décor. During World War I days, Grand Avenue was filled with patriotic music by Camp Kearney military bands and horse-drawn caissons. (Courtesy PR.)

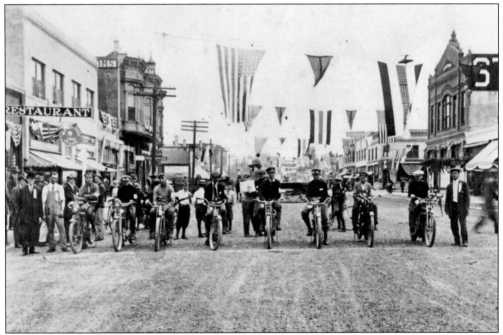

GRAPE DAY MOTORCYCLE RACE, 1912. Elmer Webb, on cycle fourth from left, was the lucky winner of the one-time Grape Day Motorcycle Endurance Race with his one-cylinder, four-horsepower Sears cycle in 1912. The course of the race is unknown, yet the event was a spectacle thanks to the relative infrequency of motorcycle ownership in early days. (Courtesy PR.)

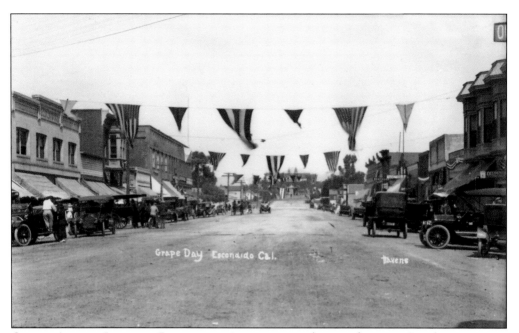

GRAND AVENUE LOOKING EAST, 1913. Visitors arriving by train for Grape Day festivities were introduced to Escondido via Grand Avenue, the heart and soul of the young city. What had been a meandering cow path was upgraded with a streetcar track and named Grand Avenue in the Escondido Land and Town Company Survey in 1886. With incorporation in 1888, Grand Avenue was widened with board sidewalks, hitching posts, and eventually car parking in this 1913 photograph.

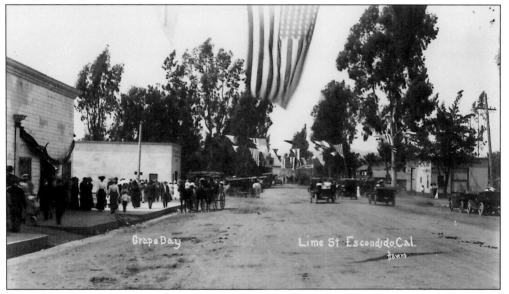

LIME STREET AT GRAPE DAY PARK, 1915. This Grape Day view from September 9, 1915, looks northward down Lime Street, now Broadway. To the left, beyond the buildings, is Grape Day Park, where most afternoon festivities were held each day. The streets would bustle with groups of people in the early hours and late afternoons, post-parade, when large picnics and grape feasts were held.

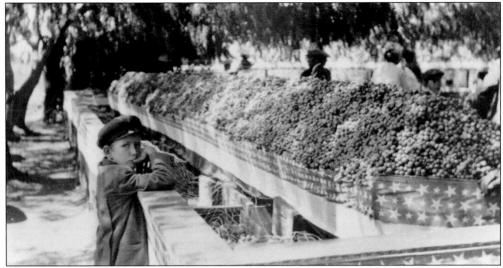

TEN TONS OF GRAPES, 1913. This unidentified youngster was caught in the act by Havens's camera wondering whether or not he should resist reaching for a bunch of grapes. One of the most popular events of Grape Day, the giving away of 10 tons of grapes accompanied by the day of fun and promotion of the Escondido valley, symbolized the generosity of locals who embraced visitors and convinced many to become residents themselves. (Courtesy PR.)

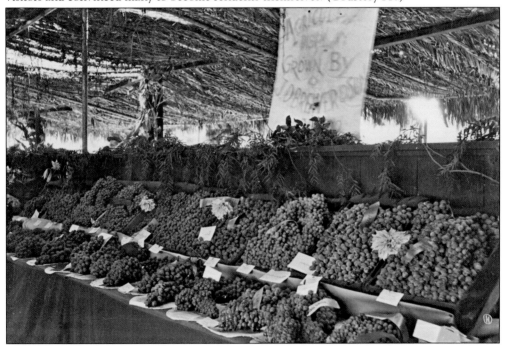

GRAPE CONTEST, 1925. D. Brewer and Sons posted a series of winning displays in the 1925 Grape Day judging contest, winning several first-prize ribbons. Grape growers during the 1920s had a limited market for their luscious fruits as Prohibition limited the manufacture, distribution, or sale of wine products from grapes. Most grapes during this period were grown for fresh produce and raisins. In the years after prohibition, citrus and avocado began tolling the death knell for the mighty muscat. (Courtesy PR.)

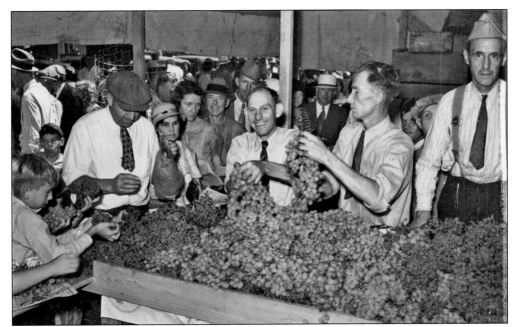

FREE GRAPES! 1939. Volunteers passed out grapes to throngs of visitors each Grape Day from booths in the park. Kids and adults alike stood queued with newspaper and Grape Day programs in hand to receive the cool treats. The tradition of giving away grapes stemmed from Bond Burning Day in 1905, when visitors to the chamber of commerce were given a souvenir box of muscats and also from the first 1908 Grape Day giveaways on the train to arriving guests. (Courtesy PR.)

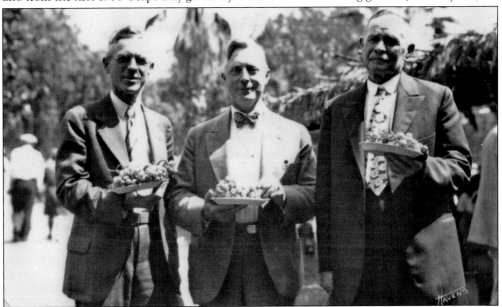

GRAPE DAY DIGNITARIES, 1929. Present at all Grape Days were the hand-shaking dignitaries of the festival, passing well wishes as they joined in an automobile procession and after the parade at Grape Day Park. Photographed dignitaries of the 1929 festival, with muscats in hand, are, from left to right, tax collector Crowell D. Eddy, Mayor Harry Clark, and Judge W. N. Bradbury. (Courtesy PR.)

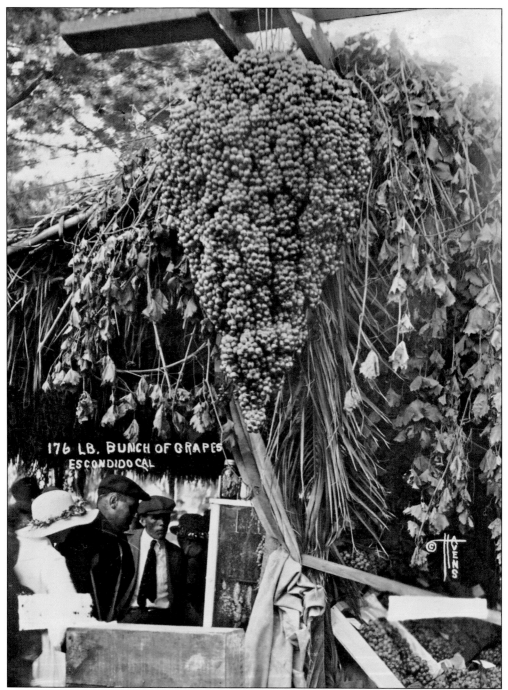

THE COLOSSAL BUNCH, 1922. As grape bunches grew bigger each year in the perfect Escondido climate, at Grape Day events, a tradition was begun as guests would try their best at the Grape Guessing Contest. A colossal bunch of grapes was created out of a metal framework to which grape bunches were tied. Grape leaves were stuffed inside and the bunch was hung prominently from a beam within Grape Day Park for all to guess its weight. The best guess would win the bunch of grapes. (Courtesy PR.)

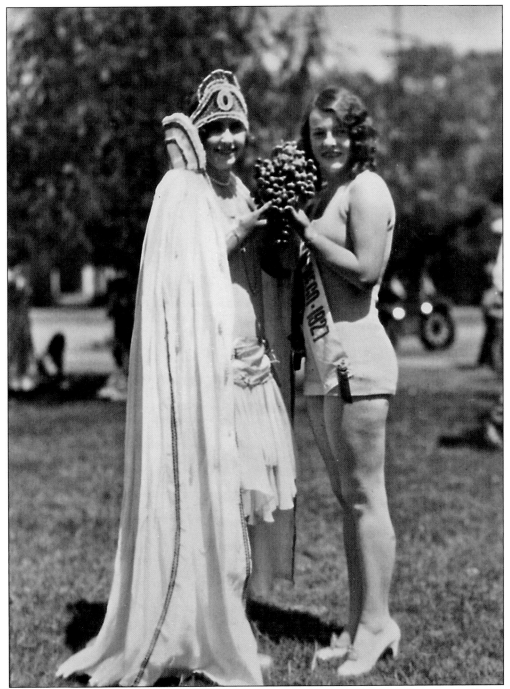

SAN DIEGO AND ESCONDIDO GRAPE DAY ROYALTY, 1927. The 1927 Grape Day queen, Vanita Stiff, and "Mermaid Miss" San Diego, Martha E. Strang, pose for Havens in Grape Day Park just prior to the afternoon parade. Strang was the bathing beauty winner of the Miss San Diego pageant. With quite the contrast in costumes, both misses admiringly display Escondido's best muscat grapes. (Courtesy PR.)

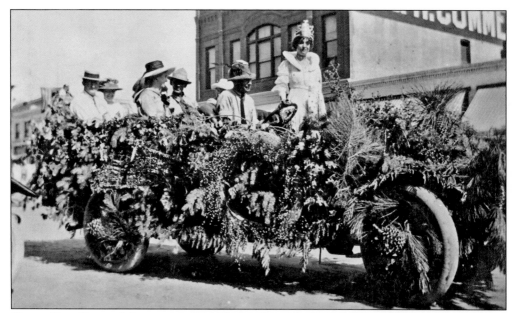

GRAPE DAY QUEEN MARGARET, 1913. Ironically with the first Grape Day, a symbolic queen was not chosen to grace the events. This tradition was not established until Havens captured Margaret Juny in 1913 as the first Grape Queen. Standing atop the Palomar Mountain stagecoach, adorned in Coulter pinecones, needles, grape leaves, and fruit, she symbolized a new tradition that Grape Day Association president W. E. Alexander proposed as homage to the king muscat. (Courtesy PR.)

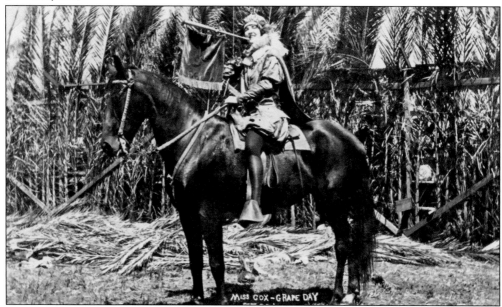

THE COMING OF THE QUEEN'S FLOAT, 1921. Vivian Cox, adorned in purple velvet medieval costume and riding a silver-saddled Chiquita, hailed the parade crowd of the coming of Queen Hope Crenshaw's float in 1921. A procession of royal subjects, often runners-up in the queen selection, attended the queen as maids of honor, bearing the finest Escondido fruits and flowers as tributes to their queen. (Courtesy PR.)

ESCONDIDO'S ROSEMARY EVANS. Rosemary Evans, daughter of *Times-Advocate* owner/publisher Percy Evans (seen on page 54), posed in many public events, including these two parade floats in 1917 and 1919. Above, Rosemary portrayed Miss Columbia, the torch lady of the classic icon of Columbia Pictures, and below, she sits on the hood of a fern- and flower-draped Ford automobile. It is unknown but likely that these images were shot during or advertising for a Grape Day festival. (Courtesy PR.)

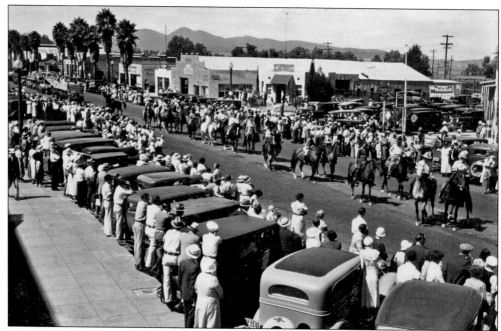

MARCHING BAND AND PARADE, 1939. Each Grape Day Parade, vehicles backed into position against curbs along the Grand Avenue parade route so occupants could comfortably watch the parade pass by from their hoods, front seats, and bumpers. The Grape Day Parade was a highlight of every year's festivities, which over the years drew up to 30,000 spectators from throughout the Southland and beyond. This 1939 parade image, from a rooftop vantage point, captures the full pageantry and regalia of the event. (Courtesy PR.)

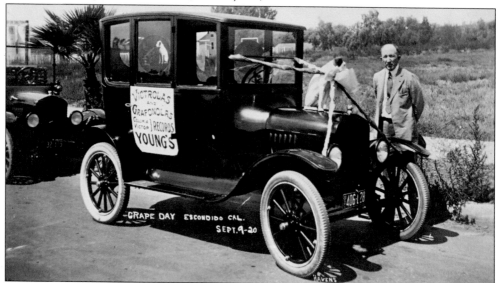

PARADE ENTRIES, 1920. Clemens D. Young, local music store owner, stands with his 1920 Grape Day Parade entry adorned with the RCA Victorola dog "Nipper" as his mascot. Many Escondido businessmen entered floats in the annual parade to gain exposure. Young's store featured musical Grafanola record players, books, stationery, and Columbia Victorolas at 128 East Grand Avenue. (Courtesy PR.)

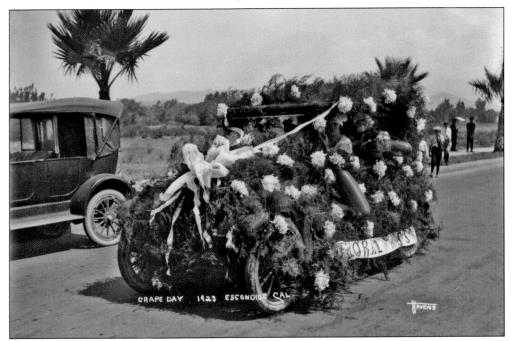

GRAPE DAY PARADE FLOATS. These entries into Grape Day Parades were perhaps more becoming of extravagancy than the typical float, but they typified the splendor that locals wished to portray of Escondido's bounty of industry, floral market, and agriculture. The below winning commercial category float, designed and entered in 1923 by Ernest Settles, road master and clerk for the San Diego and Arizona Railroad, glorifies such industry through an automobile adorned with ferns, carnations, and roses.

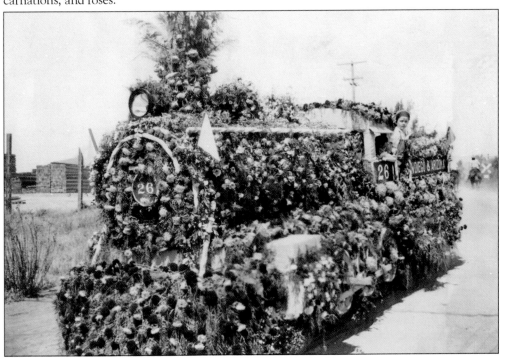

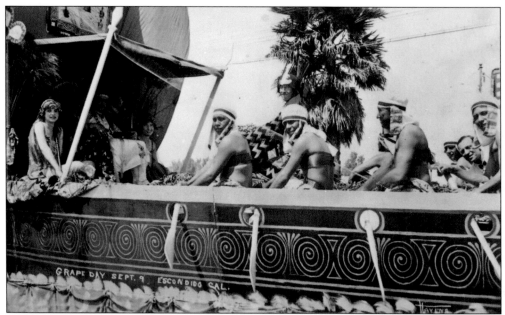

QUEEN'S FLOAT, 1926. In the year of the discovery of King Tut's tomb, the craze of Egyptian revival swept the country and became representative of the queen's float of 1926. The ornately decorated gold and purple Cleopatra-style barge, created by local optometrist Ben Sherman, carried the queen and her court of attendees up the river of Grand Avenue with local men portraying bronze-skinned oarsmen. (Courtesy PR.)

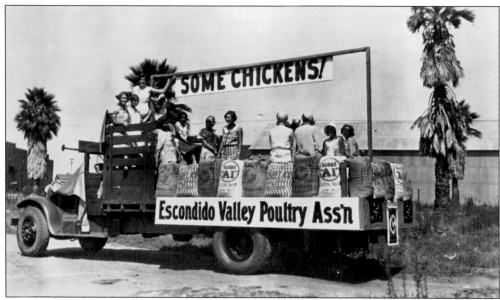

LOCAL BUSINESS FLOATS, 1928. The Escondido Valley Poultry Association float, designed by Julius Deggleman, in 1928 poked fun at the poultry industry, being lighthearted about "Chicks and Chic" with 15 young beauties posing on 80-pound sacks of A-1 Laying Mash grain bags. A goal of the Grape Day Parade, and Havens's camera, was to market and document business activities that bolstered the community. (Courtesy PR.)

Six

OVER THE YEARS
EVENTS, PLACES, AND PEOPLE

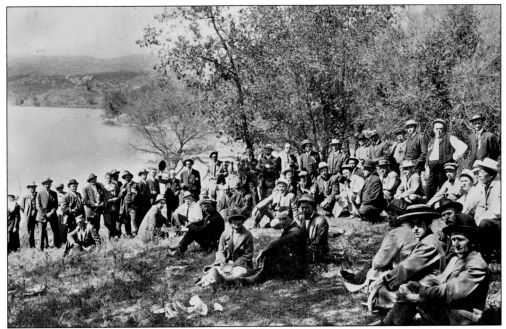

MARKETING THE HIDDEN VALLEY, 1914. In the spring of 1914, W. E. Alexander of the Escondido Valley Land and Planting Company entertained 100 realtors from around California and the West on a scenic tour of Escondido, highlighting its local businesses and infrastructure, agricultural suitability, vast lots for development, and ultimately its wonderful Southern California climate. The tour was a large success in exposing marketers to the benefits of land acquisition and led to the word being spread that Escondido was the place to be. The day ended at Bear Valley Dam for a fresh fish fry of local trout. (Courtesy PR.)

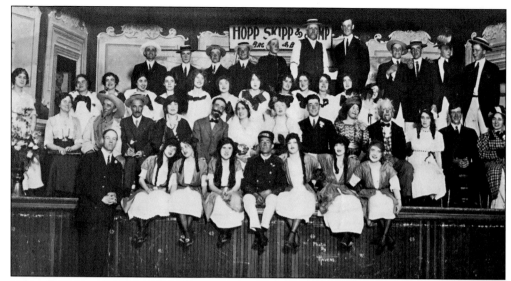

HOPP, SKIPP, AND JUMP, 1914. Havens was always on hand to photograph the casts of every public event and play during his 41 years as Escondido's unofficial photographer. Here the cast of *Hopp, Skipp, and Jump*, written and directed by Los Angeles home talent play promoter J. W. Evans, poses during a nostalgic fund-raiser in 1914. The cast was made up entirely of chamber of commerce members and Escondido businessmen and women. (Courtesy PR.)

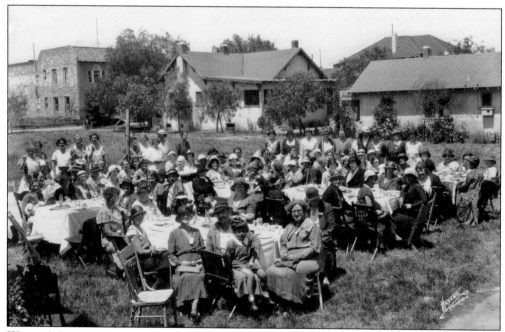

WOMEN'S LUNCH, 1930. Havens was on hand in June 1930 to capture this year-end occurrence of the Escondido Woman's Club and the East End Club gathering together for a combined luncheon in an open field south of Grand Avenue. Both groups had been organized as civic-cultural assemblies who spoke as a voice to the community through their solidarity. Each congregated to exchange ideas, share companionship, and discuss domestic issues once a month. (Courtesy PR.)

ESCONDIDO CENTENARIANS, 1918.
This well-worn and broken glass negative from August 27, 1918, captures Felicita Morales's husband, Boley, and local centenarian David Eddy as they reveled up the afternoon with old-timers in celebration of their birthdays. Boley, weak from edema and arthritis, clutches a cane while David Eddy holds flowers. In actuality, Boley's age was only speculated and David Eddy was celebrating his 100th birthday, instead of 119 and 102, their respective ages Havens etched on the negative. (Courtesy EHC.)

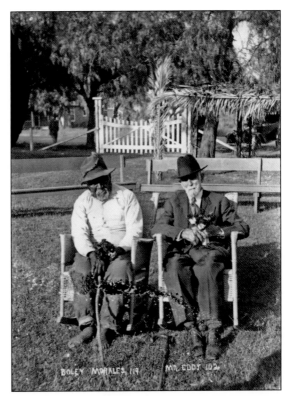

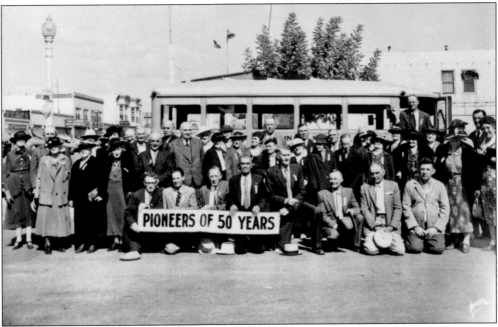

PIONEER PICNIC, 1938. Many of these pioneers were just youngsters in the early days of the 50 years of Escondido's city history prior to 1938, yet they were important figures in shaping its past and future. Havens as well ought to have posed in the photograph, as he had gained 28 years of experience as a pioneer at the time he composed this image. (Courtesy EHC.)

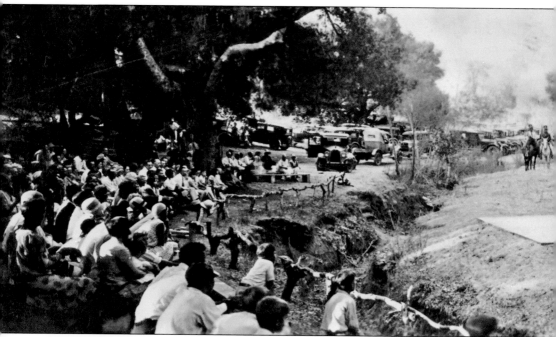

ESCONDIDO'S OUTDOOR FELICITA PAGEANT, 1927–1932. Benjamin F. Sherman, a local optometrist, authored and directed the Felicita Pageant, based on Elizabeth Judson Robert's *Indian Stories of the Southwest*. The pageant locally gained fame in the late 1920s to 1930s as an annual event in

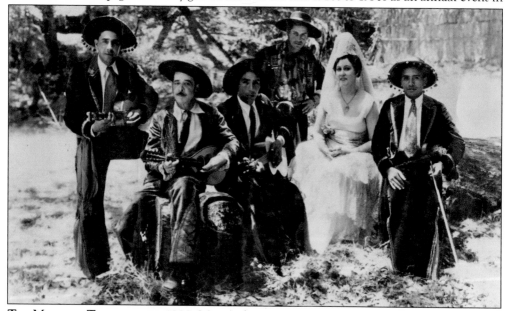

THE MEXICAN TROUBADORS, 1923. Max Atilano's Mexican Troubadors were a well recognized and loved presence at Grape Days, public events, and Felicita Pageants for many years. In this 1923 photograph at the Felicita Pageant, Senorita Paquita Cantu, wearing a traditional white gown, sang customary Mexican and Spanish ballads with the troubadours while they strolled during the event. From left to right are Max Atilano, Ted Borja, John Cosio, Frank Salcido, songster Senorita Paquita Cantu, and Pete Ruiz. (Courtesy PR.)

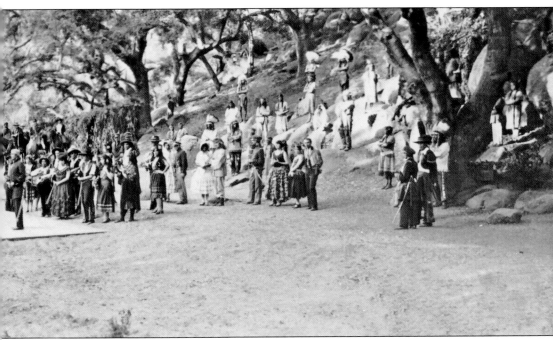

Felicita County Park, south of Escondido. The play attracted hundreds of guests, who sat under grand oaks to view the spectacle. The cast of soldiers, horsemen, Native Americans, priests, singers, and dancers, numbering 200, were all local home talent. (Courtesy PR.)

Don Caspar, one of the Felicita Pageant characters, strikes a pose for the camera. (Courtesy PR.)

FINNEY FIELD, 1925. Harold "Hal" Finney was instrumental in influencing the development of baseball in early Escondido. Acting as a captain of the city baseball team for many years during the 1920s and 1930s, he took a leading part in creating two six-team night baseball leagues locally. These teams drew such crowds to an area of northwest Grape Day Park that a permanent field was constructed in his honor with proceeds from games in 1925. Havens was on location snapping images depicting the construction and the opening night under the lights. (Courtesy EHC.)

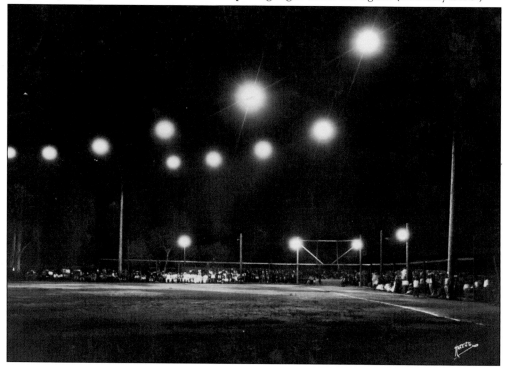

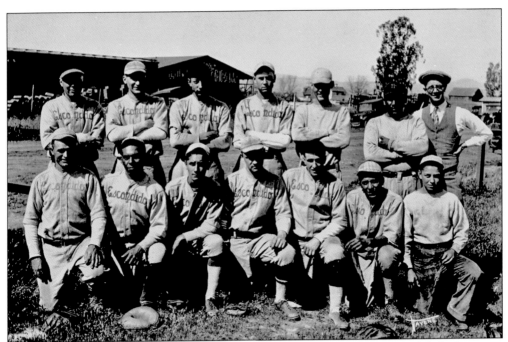

ESCONDIDO BASEBALL, 1920, AND THE FORDETTES, 1941. Baseball in Escondido had a strong following from the early days of high school sports and Grape Day exhibitions to the later days of the Night Ball Association League. Photographed above are the members of the Escondido Baseball Team at their practice field behind A. L. A. Lumber at Spruce and Pine Streets in the 1920s. Below, during the absence of many of the boys during World War II, the Homer Heller Ford Dealership sponsored the all-female Fordettes in league play with other local female teams around the Southland to continue the baseball tradition. (Courtesy EHC.)

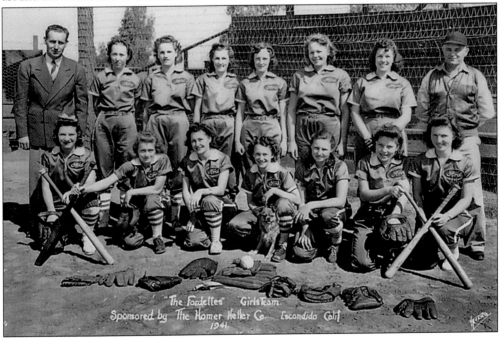

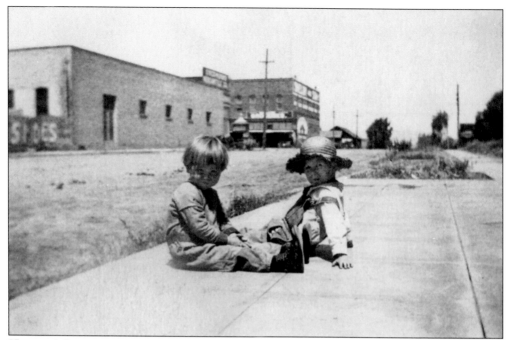

HANGIN' OUT, 1923. Louis Havens's son, Jack, and nephew Bruce Nelson hang out on the curb of the Kalmia Street Studio in 1923 watching the world go by. Louis occasionally snapped casual family shots with his smaller 2¼-by-3¼ Kodak Brownie, which was capable of composing six shots without reloading. For $21, Kodaks of such caliber became widely available in the early 1920s to the public and were sold in Havens's shop. (Courtesy B. Nelson.)

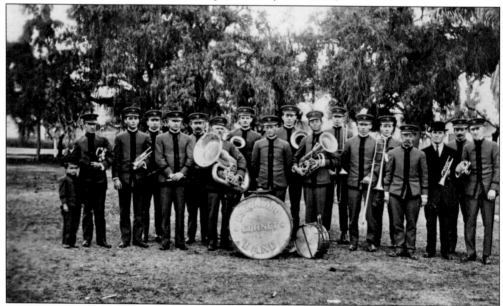

ESCONDIDO CORNET BAND, 1915. The Escondido Cornet Band was a common occurrence during every public event, festival, Grape Day, ball game, and concert. They joined with neighboring bands and musical entourages from surrounding communities. Havens was active in the band, playing the small cornet horn, as seen posed at far right. (Courtesy EHC.)

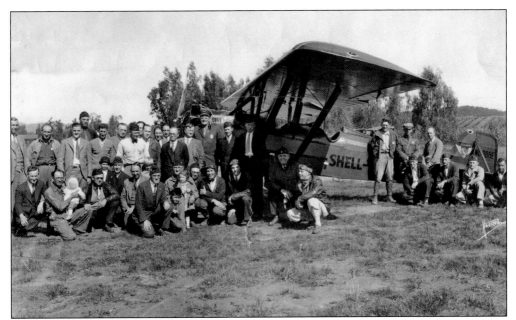

WINGED VISITORS, 1935. Grape Day greetings from San Diego were sent by flying machine in 1935, as Grape Day revelers pose with the unidentified pilot in a field northwest of Grand Avenue. During the 1920s, death-defying stunt flying became a regular event. In the 1930s, airplane rides in craft such as this were a penny per pound of weight. At center back, Constable Andy Andreasen (also seen on page 113) boasts a smile. (Courtesy EHC.)

THE CIRCUS IS IN TOWN, 1917. All Escondido children and families were treated to a dual day event in 1917 as two circuses paraded their menageries down Grand Avenue in advance of their shows. Al G. Barnes Wild Animal Circus performed March 9 and was followed by Cole Brothers' Big Three Ring Trained Wild Animal Show the following day. Each show gave afternoon and evening tent performances following their pre-show parades. Photographed is the Cole Brothers' company as it made its way past storefronts on Grand Avenue. (Courtesy PR.)

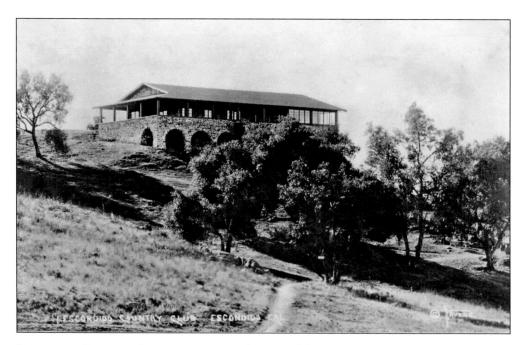

ESCONDIDO COUNTRY CLUB 1924–1931. The Escondido Country Club evolved in spring 1924 as 100 members bought 160 acres of Cassou family farmland on the northwest edge of town. The course came into existence by that July thanks to the efforts of members armed with hoes, rakes, and wheelbarrows to build the layout and stone clubhouse. The course consisted of nine holes, teeing ground, fairways, sand traps, and greens. The club was the center of many social events for several years, yet the Depression sealed its demise as it was sold in 1931, remodeled into a home, and destroyed by fire in 1957. Today's club exists at a different location, having been reestablished in 1965. (Courtesy PR.)

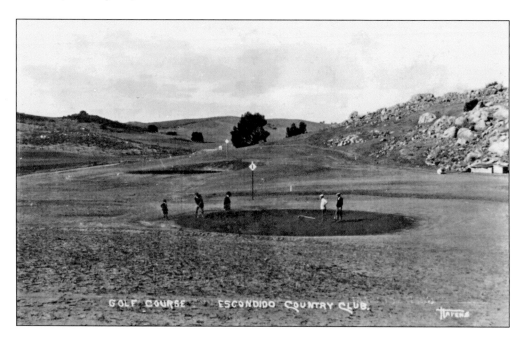

ESCONDIDO BUSINESSMEN AND GOLF. Many a business deal was brokered through a game of golf, and as seen in these images by Havens, it was also a prime social event to see and be seen by others at the country club. Members of the Rotary Club and local chamber of commerce gather for a tournament in 1924 to enjoy the new fairways. Both men and women competed in casual and formal play and tournaments and were subject to Havens's request to pose for a photograph. (Courtesy EHC.)

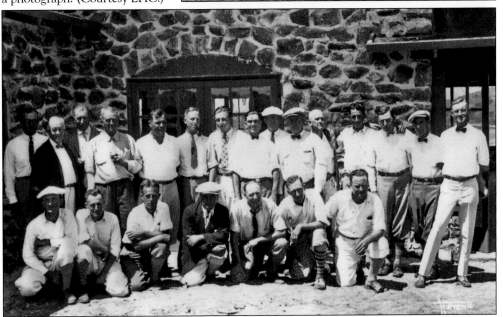

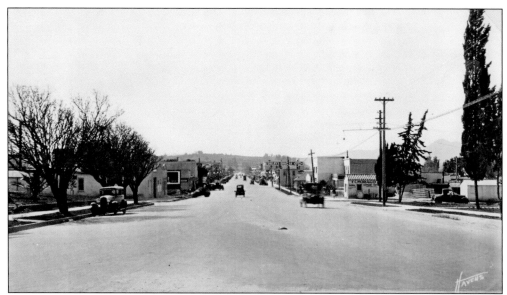

PAVING OF GRAND AVENUE, 1913. Escondido had grown considerably by the time Havens stood on the top of Grand Avenue at Hotel Hill to capture this view westward. Escondidans, having endured almost 30 years of dust and mud, had their wishes met when Grand Avenue was macadamized in 1913, thus paving the way for the automobile to become the preferred mode of transportation in the near future. (Courtesy PR.)

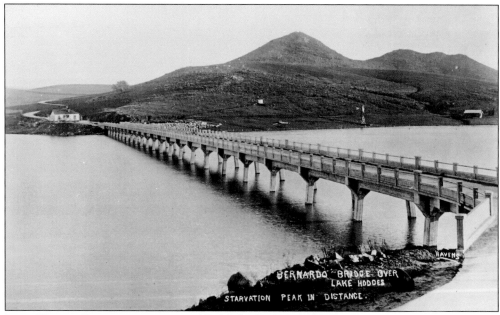

LAKE HODGES BRIDGE, 1927. Water filled Lake Hodges within a season after the dam was built, creating recreation opportunities at the Hodges Fishing Camp and Dance Pavilion on the south shore. The location of the camp was at the base of Battle Mountain, also known as Starvation Peak, near Pomerado Road and Interstate 15. The old two-lane road crossed towards Poway with the current 10-lane interstate now crossing left to right on the distant shore to San Diego. (Courtesy PR.)

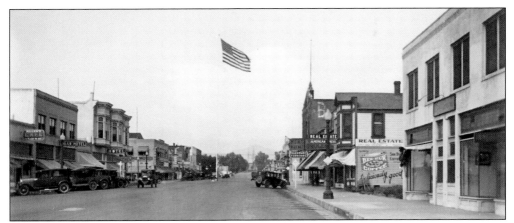

ESCONDIDO'S FLAGPOLE, 1931. Escondido's tallest structure stood as a sentinel over the downtown district for 23 years at the intersection of Grand Avenue and Lime Street. The pole was a gift to the city from the Consuelo Lodge of Free Masons in tribute to the 150th anniversary of Flag Day. The 100-foot pole and its concrete base eventually became the target of numerous automobile collisions and was deemed a hazard and removed in 1950. (Courtesy PR.)

POWAY GRADE, 1914. The Poway Grade, between Escondido and San Diego, now a portion of State Highway 56 and Espola Road in Poway, was a main route to San Diego in the early days. The grade snaked its way south of Escondido, west of Ramona, and into Poway for destinations distant. Many an automobile could not make it up the 8.3-percent slope easily, yet the car on the shoulder was not stranded but rather waiting for Louis Havens to compose his photograph. (Courtesy PR.)

THE ESCONDIDO FLOOD OF 1916. In the wake of 19.55 inches of rain falling during the month of January 1916, the region's ground was saturated beyond capacity and could not bear much additional rainwater. The Escondido River swept anything in its path downstream, leaving locals living near the river's edge scrambling for high ground or rescue. (Courtesy PR.)

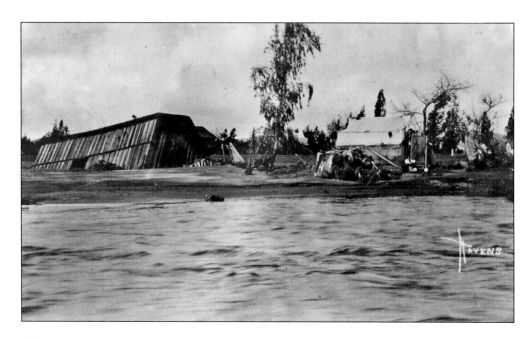

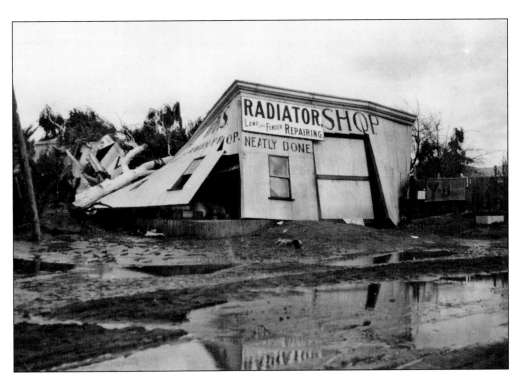

BUSINESSES COMPROMISED, 1916. Water flowed 18 inches over the face of Bear Valley Dam and all bridges in San Diego County were washed out, leaving no trains or traffic to move. The images captured by Havens on January 27 depicted the destruction: Buildings were toppled, tracks twisted, storefronts were flooded, and crops lost. No trains for a month into Escondido meant delayed crops, lost revenues, and rationing of goods. (Courtesy PR.)

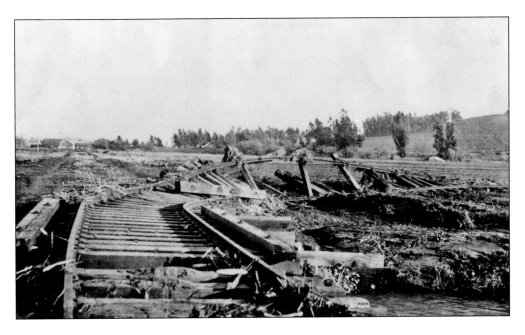

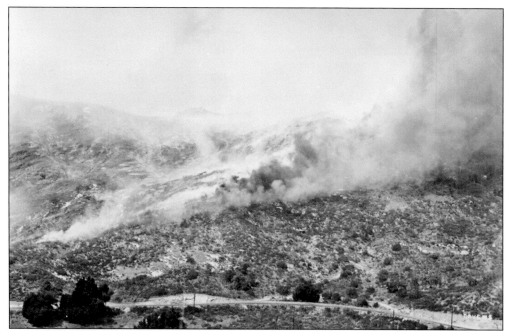

LIVING WITH FIRE, 1938. Wildfires have always been a natural occurrence in the Southland, and with development, their intensity and threat to local resources only gained significance. Havens captured this brushfire from Lake Wohlford Road looking north to Stanley Peak, along the Valley Center Grade, in 1938. Before today's technology, watersheds, ranches, and farms were even more at the mercy of the wind and flames. (Courtesy PR.)

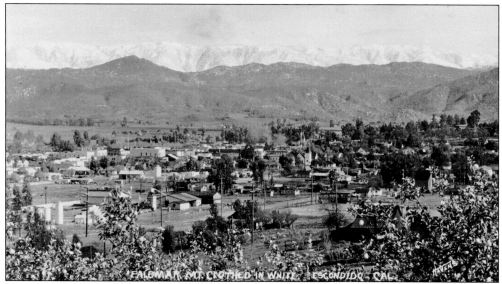

BALMY ESCONDIDO WINTERS WITH SNOW, 1930s. This picturesque postcard scene captured by Havens of Escondido and "Palomar Clothed in White" epitomized the balmy winter California climate. Scenes such as this made their way to winter-weary Easterners and convinced them to catch a train to Southern California for a visit. This view captures Escondido from Howell Heights looking east over citrus and rolling hills to the snowcapped Palomar Mountain in the distance. (Courtesy EHC.)

Seven

INSIDE HAVENS' STUDIO
EXHIBITION, WORK,
AND PORTRAITURE

ESCONDIDO CITRUS. This double exposure on one glass negative during a studio photo shoot in the mid-1920s could have been no more than Havens experimenting with composition and image bracketing, but it became a fine example of his eye for capturing many facets of Escondido's history. Such images of detail are hallmarks of the diversity that Louis strove to embody in his photography, adding special significance to the history of Escondido and its famed citrus industry. At left, young Valencia oranges share negative space with juvenile Eureka lemons at right.

GRAPE DAY PRIZE POULTRY, 1937.
In the September 9, 1937, Grape Day Poultry Show, a shy girl, Fredricka Darling, entered her Leghorn pullet, winning the Sweepstakes Gold Cup. She had offers to sell her prize pet but decided to keep it for herself as it was the only perfect pullet of 20 unhatched eggs that she hand raised. After winning her Gold Cup, she entered Havens's studio to pose with the prize entry. (Courtesy PR.)

POSING WITH A FINE HORSE, 1917. An unidentified local poses dressed in his Sunday best with one of his draft horses for Havens's camera just prior to the 1917 Grape Day Parade in Grape Day Park. Prized workhorses such as this one were an integral part of everyday life for generations.

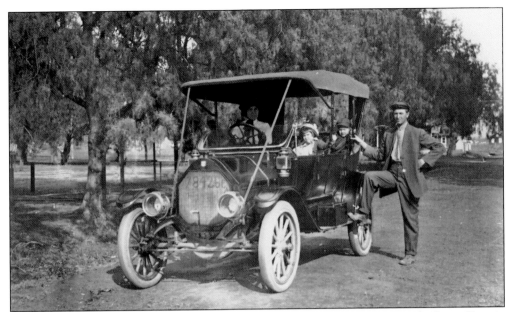

EARLY ESCONDIDO FAMILY AUTOS ON GRAPE DAY. Autos were a rarity in early Grape Days in Escondido. The lucky owner of an automobile would have his photograph taken with his family by Havens just prior to entering their car, decorated or not, into the Grape Day Parade and Auto Show. Everybody was dressed for this occasion in their best from tip to toe.

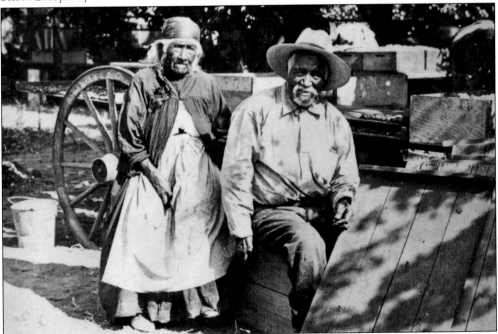

FELICITA AND MORALES. A familiar Escondido sight on their donkey was San Pasqual Indian princess Felicita with her husband, Boley Morales. The destitute old couple was befriended by Elizabeth Judson Roberts, who cared for them and wrote a book, *Indian Stories of the Southwest*, based on Felicita's local accounts. Felicita passed in 1916, and in the 1920s, a pageant was written in her honor (as seen on page 90). (Courtesy PR.)

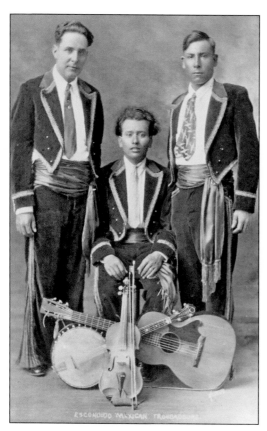

GRAPE DAY PORTRAITS. In addition to the outdoor festivities and gatherings of Grape Day, performers would come to Havens' Studio for formal portraiture in their costumes to record the moment in time. Photographed below is Grace Foncannon Brewer in customary Spanish costume posed after singing "I Love You California," which became a Grape Day tradition. Pictured left are the Mexican Troubadors, with Max Atilano at center, also seen on page 90. (Left, courtesy PR; below, courtesy EHC.)

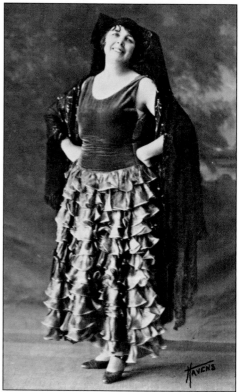

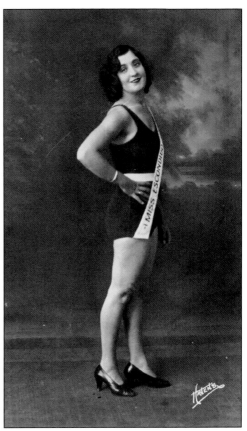

MISS ESCONDIDO, 1933. Rose Verello sits in Havens' Studio for formal portraits in her Miss Escondido swimsuit costume in 1933. Havens had a knack for composing images with classic style and energy, working to embellish the subject's character and creating stunning vignettes of both composition and lighting. (Below, courtesy EHC.)

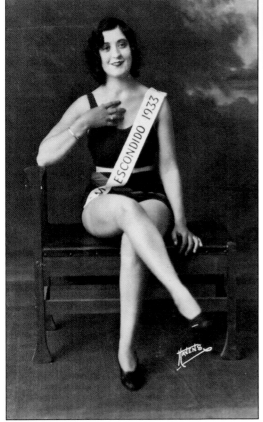

JACK HAVENS. Louis Havens's son, Jack, was an often-photographed subject in the studio, as these early-1920s images reveal. Both Jack and his cousin Bruce Nelson, on the facing page, had a great energy in front of the camera and, coupled with Louis's skill with the lens, captured a traditional feeling of warmth and youthful vitality through his work. These images of Jack are perhaps some of the most charming works that his studio produced over the years but are certainly not the only examples. (Courtesy P. Gillespie.)

HAVENS FAMILY KIDS. Bruce Nelson, son of Louis Havens's sister Edith, poses at right and below with Jack Havens at the ever-present craftsman-style chair that graced most of Havens's studio photographs. Havens' Studio used natural light from skylights above to assist in composing softly lit, richly contrasting images that portrayed the subjects in a relaxed and glowing natural character. (Courtesy B. Nelson.)

CHILDREN'S PORTRAITURE. Havens, being the only long-standing photographer in town, watched many children and families grow through the years via his lens. He was constantly called on for family events, weddings, births, baptisms, family photographs, and graduation snapshots. His specialty of working with children was unsurpassed, as his quiet and warm demeanor and comfortable studio setting were instrumental in gaining the right shot. (Courtesy PR.)

TYING THE KNOT. Havens' Studio composed its fair share of wedding photographs in its years of business, as many who tied the knot went down to pose shortly after their ceremonies. Havens also took his camera to outdoor events and captured functions and ceremonies quite regularly. Pictured right is the Earl and Geraldine Squier post-ceremony wedding party of 1942; below, Mrs. Esther Hoffman poses with husband around 1930. (Right, courtesy G. Beckman; below, courtesy EHC.)

Havens Elders. Josephine and George Havens, Louis's parents, are seen in studio vignette photographs in approximately 1914. Louis conducted a fair amount of family photography during his years as a professional. Another shot of the family can be seen on page 24. Havens's parents lived on a large walnut orchard in Santa Ana, Orange County, to which Louis and Esther retired in 1944, operating a small framing and photograph business thereafter. (Courtesy Peg Gillespie.)

Frances Beven Ryan, 1914. Frances Beven sat for Havens in 1914 as a young 13 year old on the cusp of her graduation as the class of 1915 from Orange Glen Grammar School. She returned at 17 for her Escondido High School senior photograph in 1918. Frances Ryan indirectly became an impetus for this book as her foresight into creating an Escondido historical archive, via the Pioneer Room, assisted greatly in researching Louis Havens and early Escondido history. (Courtesy PR.)

ANDY ANDREASEN, 1930. Andy Andreasen was one of Escondido's most well-known and respected figures in early days. He held many positions varying from humane officer and city marshal to mayor and chief of police during his years of community service. In this c. 1930 Havens's studio photograph, he poses uniformed as city marshal. Although a tall and looming personality in this studio image, his presence was perpetually humanitarian and warm natured. (Courtesy EHC.)

ED STILES, 1920S. Ed Stiles poses at Havens's studio in his high-cinched gun belt as town constable around the early 1920s. Little is recorded of Ed's participation in the law keeping in early Escondido, but typically the town constable also had duties of dog collecting, lighting street lamps, conducting plumbing inspections, and maintaining the jail facilities. (Courtesy PR.)

ED GODDARD: EHS HALL OF FAME ATHLETE, 1933. Ed Goddard poses for Havens in his multisport attire in 1933. He was a triple-threat—as a football player with skills at passing, running, and kicking and as a three-sport star in football, baseball, and track. Upon graduation from EHS, he aspired to three All-American Honors at Washington State, playing a short pro-football career as first-round draft for the 1937 Brooklyn Dodgers and baseball for Cincinnati's minor league. (Courtesy EHC.)

Eight

GROWING WITH THE TIMES
DOCUMENTING ESCONDIDO'S EDUCATION

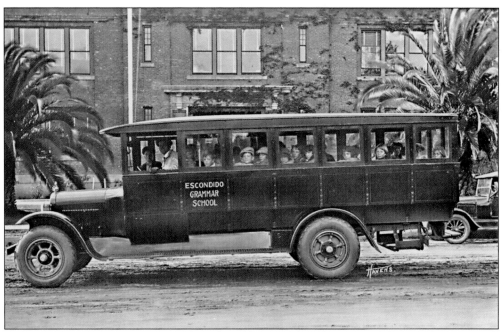

ON THE WAY TO SCHOOL, 1919. Jack Stoft and his youthful riders stopped for a quick photograph in the Escondido Grammar School bus in the mid-1920s. They are posing in front of Escondido Grammar School at Fifth Avenue and Broadway, which is seen on page 118. Stoft, a retired Alaskan merchant, drove the bus for years, transporting Escondido children to and from school activities. (Courtesy PR.)

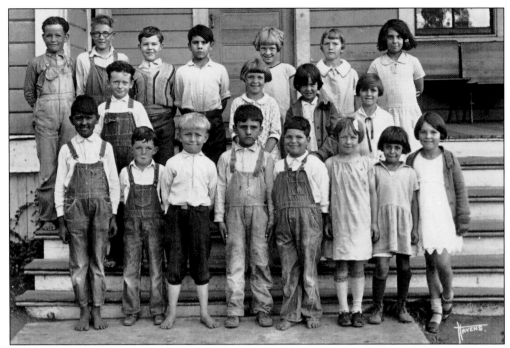

CLASS PHOTOGRAPH DAYS. Havens did not only photograph Escondido students, but also the San Marcos School District. The kindergarten class of 1927 (above) is captured on the stairs of Richland Elementary. The Fifth Avenue Grammar School graduating class of 1921 was photographed in the Kinema Theatre with full floral pageantry. Students had to keep from being restless when faced with Havens's camera as he ignited powder to take the slow-exposure flash photographs. (Courtesy PR.)

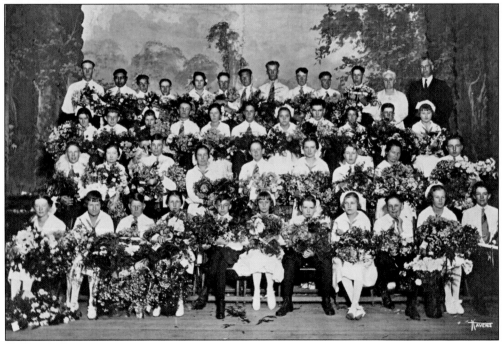

FIFTH AVENUE SCHOOL SPRING PAGEANT, 1928. As uncomfortably cute as these first graders appear, they were part of an assigned Spring Pageant that Fifth Avenue Grammar School held each May during the late 1920s. These children posed in a springtime skit depicting the bounty of local nature and its fruits of both flora and fauna as cultivated by man, in this case a farmer. (Courtesy EHC.)

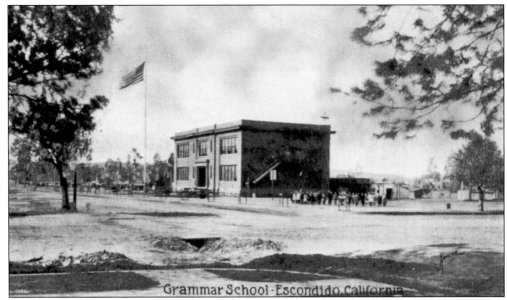

FIFTH AVENUE GRAMMAR SCHOOL, 1920. The Fifth Avenue Grammar School held its first day of classes on October 10, 1910. The two-story schoolhouse was constructed as a replacement for the Lime Street School, which had been razed two years after construction because of subsidence, being adjacent to the Escondido Creek. Fifth Avenue School, constructed similarly of red brick, stood until the 1933 Long Beach earthquake rendered it unsafe in a statewide inspection. A 1937 demolition was followed by the 1938 Central School, which stands today. (Courtesy R. Dotson.)

ORANGE GLEN GRAMMAR SCHOOL, 1936. Originally Oak Glen School, Orange Glen was located in Escondido's east end among old Engelmann oaks. It was first established in 1892. The school educated local east-enders that lived far from town. In 1914, Orange Glen withdrew from the Escondido Elementary District over tax allocation disputes, forming its own district. The schoolhouse, photographed by Havens in 1936, was built in the mission/Spanish Revival style, surviving into the 1980s when it fell to development. (Courtesy PR.)

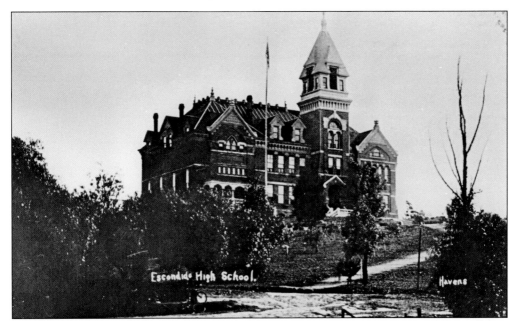

ESCONDIDO HIGH SCHOOL, 1918. EHS stood for 33 years at Second Avenue and Curve Street as an icon of educational prominence. Overseen by superintendent-principal M. W. Perry, seen on page 126, the high school boasted a swimming pool dug and finished by students in 1909. The curriculum was serious. Studies such as chemistry, physics, algebra, geometry, botany, zoology, Latin, German, Greek, English, and history occupied the time from 9:00 a.m. until 4:00 p.m. each school day. Sports came after 4:00 p.m. as extracurricular activity. (Courtesy PR.)

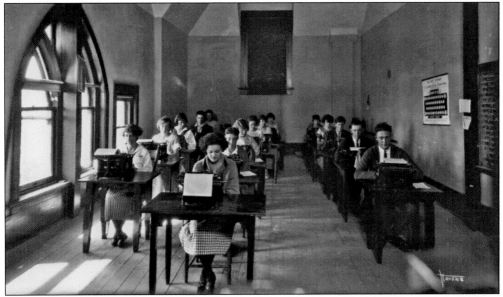

LEARNING TO TYPE, 1926. A far cry from today's word processing technology, these students in 1926 are learning on the latest LC Smith and Brothers front-strike typewriters in the upper floor of Escondido High's brick building. The soft lighting from the windows combined with the high ceilings and low reflection composed a perfect range of tonal values. This image was one of the few that survived perfectly intact after being left in a pile of debris from an abandoned barn.

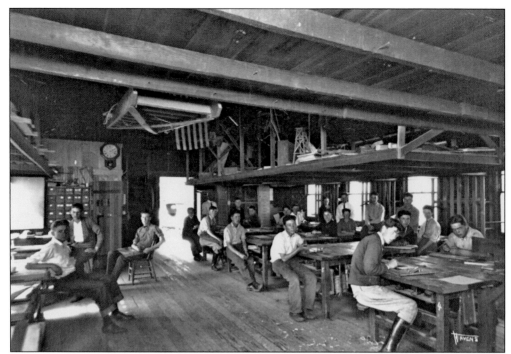

EHS Vocational Training, 1914. Vocational training at EHS was a popular part of a student's curriculum. Woodworking, architectural drafting, domestic sciences, and other vocational coursework were beneficial in exposing students to technical trade skills. Both genders worked together to create imaginative pieces of furniture and arts and crafts. Woodworking pieces were created in the then-popular mission style, which ironically is just as popular almost 100 years later at exponentially higher prices. (Courtesy PR.)

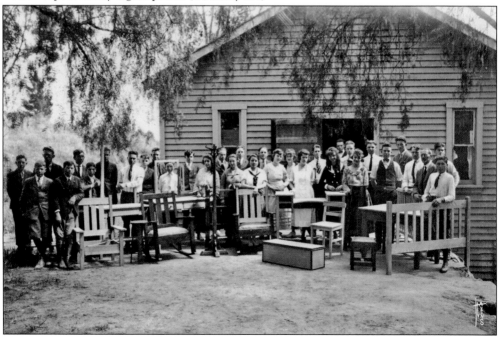

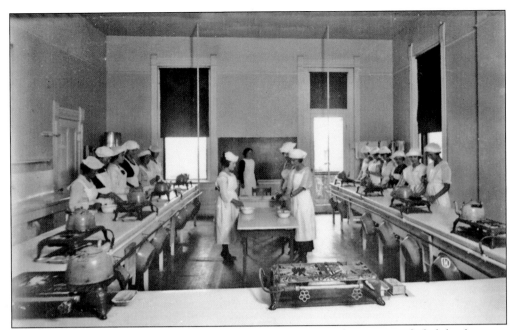

DOMESTIC SCIENCES, 1920. Part of Escondido High's vocational training included the domestic sciences for female students. Such classes were typically three years' duration in a student's curriculum with the goal of giving young ladies the necessary skills for the employment thought appropriate for the time. Ms. Wilkinson's class in 1920 poses for Havens's camera and flash to compose a difficult photograph because of the extreme light from the windows.

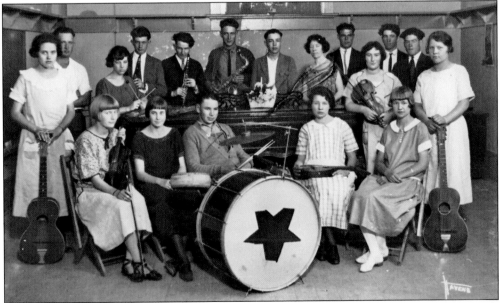

EHS ORCHESTRA, 1922. The high school orchestra, caught in this practice day photograph inside the old EHS building, had the task of playing for different organizations, speakers, and shows locally. They studied and practiced light opera pieces such as those by Victor Herbert and Sigmund Romberg. They also combined presentations with glee clubs and other high school musical groups such as Poway High School's chamber orchestra.

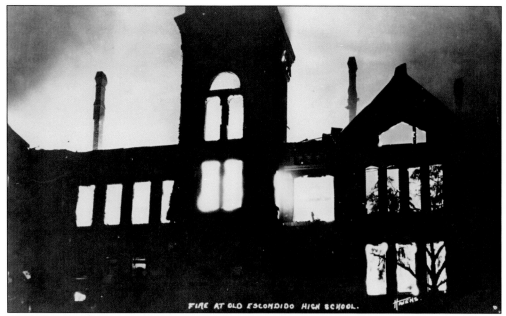

EHS Fire, 1929. Escondido lost an old friend Sunday, May 23, 1929, at 10:45 p.m. when city folk, accustomed to fire "practice night," soon realized volunteers were racing to old EHS to fight the real thing. The Escondido Fire Department and their new shiny truck, Betsy, lost the battle because of low water pressure and overheated timing gears. The three-hour fight was a total loss to the landmark and past USC Seminary. Speculation still surrounds the cause, yet possibility looms that it was due to an arsonist who was lighting a string of fires locally at the time. (Courtesy PR.)

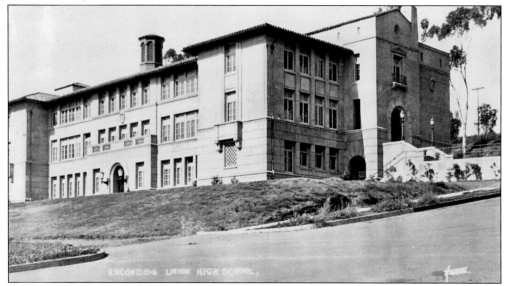

Growing with the Times, 1927. Students and instructors made the move to their new digs as Escondido High School expanded and modernized facilities with a new campus building opening March 22, 1927. The concrete building stood for 28 years until the school district declared the structure seismically unsafe amid fears of earthquakes. Ironically on demolition day, the structure would not fall easily to the wrecking ball, dispelling speculation. (Courtesy PR.)

EHS BAND, 1931. The Escondido High Band poses on the back slope behind the campus vocational building for the 1931 *Gong* yearbook photograph. Havens always composed groups skillfully, incorporating symmetry and style. He created crisp images with great depth of field, mastering the available lighting and ultimately the limitations of his box camera. (Courtesy EHC.)

EHS CHAMPION MARCHING BAND, 1938. The EHS Marching Band in the 1930s poses inside the multipurpose auditorium in 1938 for their yearly photograph. They won high acclaim in the late 1930s, being judged a championship marching band in numerous events. Under direction of Lester Schroeder, the musicians sported their sharp-looking black-and-orange uniforms at every public event and Grape Day. (Courtesy PR.)

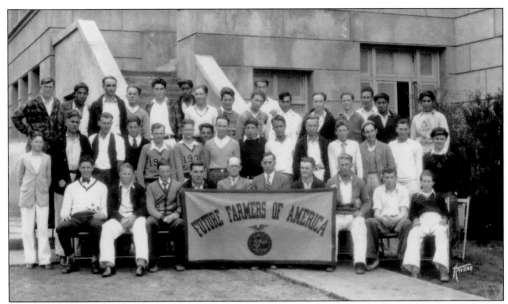

EHS FUTURE FARMERS OF AMERICA, 1931. The Future Farmers of America had a strong standing at EHS as the enrollment grew from 13 to 40 in 1930–1931 alone, despite the burning of the department headquarters during the EHS fire in 1929. The students' projects included avocado and citrus ranching, landscaping the school grounds, and serving as judges for various agriculture projects. Presidents of 1930–1931 were William Lawrence and Glenn Baker. (Courtesy EHC.)

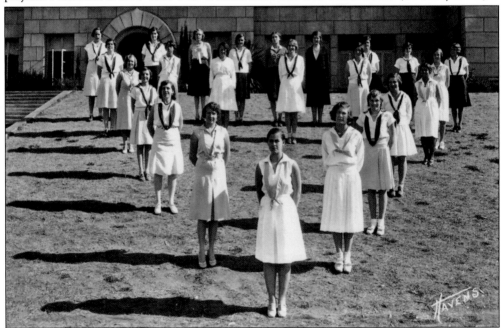

EHS GIRL RESERVES, 1931. "The slogan of the Girl Reserve triangle of the Escondido Union High School is to create a Christian fellowship among the girls of our high school," according to the yearbook passage in 1931. The girls, photographed by Havens in their signature triangle of unity, gathered and performed in various school activities around the county and the Southland. (Courtesy EHC.)

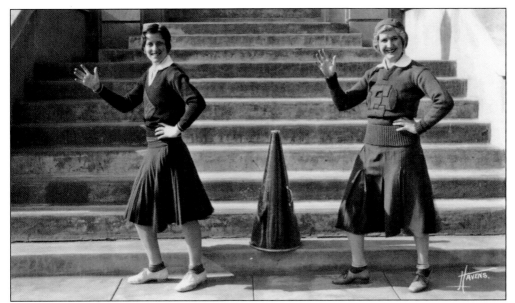

EHS Cheer, 1931. EHS varsity cheerleaders Lucille Russell (left) and Jessie Spencer strike a rallying pose on game day during the fall of 1931. It could be assumed that Jessie is not prepared to do back flips in her heeled saddle shoes, as cheer squads used more of their lungs through bullhorn amplification in days prior to stadium sound systems. Their glowing presence along with their smiles helped pep the crowd. (Courtesy EHC.)

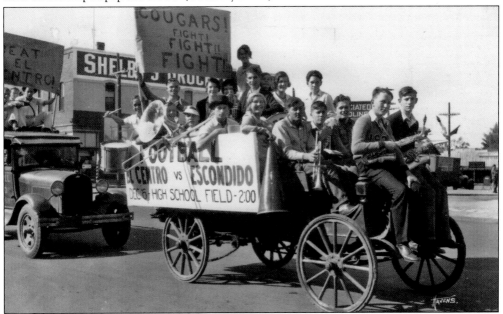

The Big Game Day Rally, 1930. The EHS Cougars were pinned against rivals El Centro in the Southern California Minor Division League Championship on December 6, 1930, at High School Field. The Cougars fought hard to battle until the end of the game, when El Centro scored two touchdowns in the last minutes. EHS lost no prestige in losing 20-6 but gained standing by the way they played and the way they boosted the team with their support rallies all week prior to the game. (Courtesy PR.)

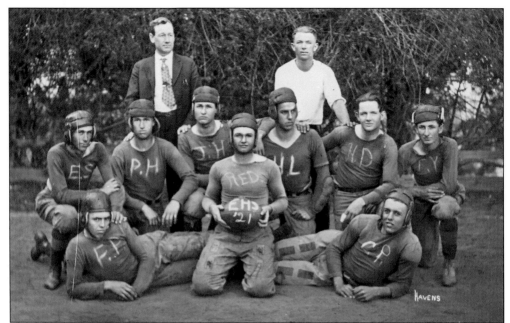

EHS FOOTBALL, 1921. Sports were extracurricular activities in early days, as schooling was for textbook learning, not play. Students had to conform to strict time schedules, carried full curriculums, and found quickly that sports were secondary to learning and ultimately doing chores at home. These senior footballers of the EHS 1921 team are sporting the latest in homemade uniforms with principal and head coach M. W. Perry in the background.

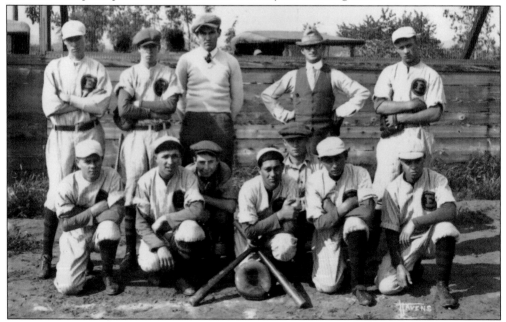

EHS BASEBALL, 1925. This lost negative, found in a rubbish pile, depicts the EHS varsity baseball team of 1925 in their game attire. Ironically these fragile glass negatives survived relatively intact and printed quite clearly for being exposed to dirt, moisture, and years of unknown storage conditions. Note the coach even carries a glove during warm-ups before the game.

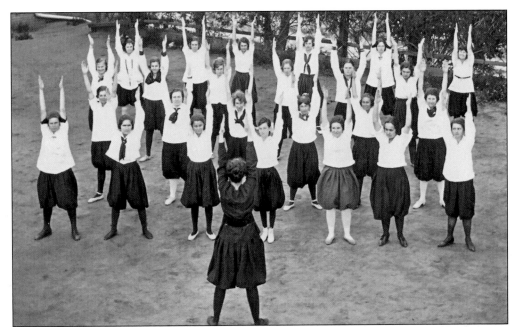

GIRLS' GYM, 1922. Gym class has certainly come a long way since 1922, when these EHS coeds were captured by Havens with his box camera. Homemade bloomers and blouses were the required uniform for young ladies, who participated in gender-segregated activities. Havens was a master of recording local events, even as simple as everyday activities. Negatives such as this may have never been printed for the public.

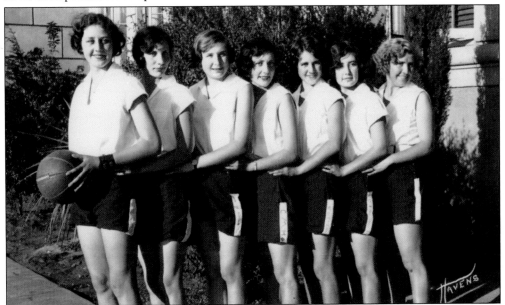

EHS GIRLS BASKETBALL, 1931. The EHS girls' varsity basketball team posed for the annual team yearbook photograph outside the new high school building in winter of 1931. The team photographs that Havens commissioned for Escondido High School over the years were always masterpieces of composition and thorough in tonal values and contrast, despite conditions of poor lighting. (Courtesy EHC.)

DISCOVER THOUSANDS OF LOCAL HISTORY BOOKS FEATURING MILLIONS OF VINTAGE IMAGES

Arcadia Publishing, the leading local history publisher in the United States, is committed to making history accessible and meaningful through publishing books that celebrate and preserve the heritage of America's people and places.

Find more books like this at
www.arcadiapublishing.com

Search for your hometown history, your old stomping grounds, and even your favorite sports team.